Lighting Techniques for # HIGH KEY
PORTRAIT PHOTOGRAPHY

NORMAN PHILLIPS

AMHERST MEDIA, INC. ■ BUFFALO, NY

► DEDICATION

I have often wondered how authors decided on whom to dedicate their work; we meet, and work with, and learn from so many people who offer support in so many ways. Life has a way of presenting us with many challenges, some that we might not overcome without the intimate and private support of those closest to us. Their encouragement sometimes is less verbal than the power of their presence. That presence is pervasive and prohibits even thoughts of failing.

My family, each and every one of them, has always been there for me, but two have been indispensable pillars of support: my wife Sandra and my mother Edna. It has been said that behind every great man there is a great woman, and while I can not lay claim to the greatness that inspired such words of wisdom, from my point of view the notion behind it is undeniable. My wife, a nurse of the highest caliber, has dignified my presence at banquets and presentations and gracefully tolerated my addiction to this incredible profession. My mother is an inspiration, demonstrating moral strength and incredible fortitude.

So this dedication first goes to those two incredible women and then to each member of my family: to my sisters Sheila, Elaine, Carolyn and Vivienne, to my brother Al, and to my children, Ivan, Leon and Daniel, each of whom have proved to be smarter than their father—most probably because of their mother! Perhaps I owe much more than I ever thought to my sister Sheila, for it was she who thrust a camera into my hands and started me on what has become an incredible, on-going journey of creativity.

But this dedication would not be complete if I failed to note that countless photographers, beginners and masters and at all stages in between, have contributed—some in a major way and some to a lesser degree—to the growth and maturity of this photographer. So, additionally, I dedicate this work to all those who have touched me throughout my career.

Published by:
Amherst Media, Inc.
P.O. Box 586
Buffalo, N.Y. 14226
Fax: 716-874-4508
www.AmherstMedia.com

Publisher: Craig Alesse
Senior Editor/Production Manager: Michelle Perkins
Assistant Editor: Barbara A. Lynch-Johnt

ISBN: 1-58428-075-1
Library of Congress Card Catalog Number: 2001 133139

Printed in Korea.
10 9 8 7 6 5 4 3 2 1

TABLE OF CONTENTS

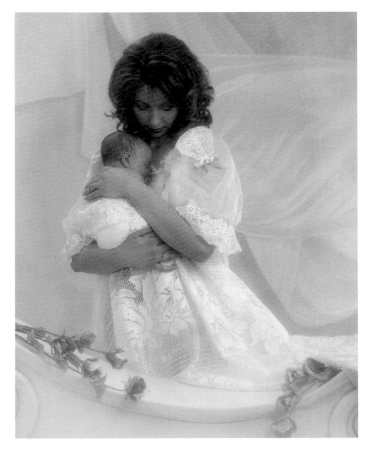

Chapter 11

MODIFYING THE BACKGROUND .68

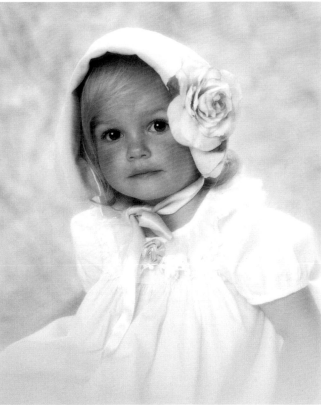

Chapter 12

OUTLINE TECHNIQUE .78

Chapter 13

WINDOW LIGHT .81

ACKNOWLEDGMENTS

Most of us, at one time or another, dream of writing a book—maybe about a life experience or, more romantically, a novel that might become a best-seller. Very few of us will ever fulfill that dream. During the past twenty years I have written countless articles that have been published in photography magazines and newsletters. I have also written and published manuals. I have even scripted a program for Britain's Independent Television. All have been so well received that it is possible I am, in fact, doing something right. It has even been suggested that I have a talent as a writer. I am fortunate insomuch as I can produce short pieces at the drop of a hat. (Sometimes I have, of course, upset the proverbial applecart and taken the flack I deserved.)

But writing a book, even one on a subject in which I have some expertise, is a different kind of challenge. There is no room for romancing when you aim to be technically informative and provide information that can be understood and then put into practice. Because of this, I have received help that needs to be recognized.

I must first thank Bill Hurter, editor of *Rangefinder* magazine and an accomplished author in his own right. I have written so much for Bill and have received so much insight from my conversation with him. There are few who are more knowledgeable than Bill, not only when it comes to the written word, but in the world of photography in general. Bill waded through my first manuscript and made many suggestions for improvements and clarification. He drew attention to an error that is so easy to fall into: assuming the reader will understand certain text without adequate explanation. Thanks Bill.

I also must thank Kim and Peggy Warmolts, Jeff Lubin, Edda Taylor and Dennis Craft for providing images for this book. I could not have covered all the areas I wanted to without images from world-class, award-winning photographers such as these. Each photographer was selected for his or her unique talents and outstanding images. Each provided me with images that helped to illustrate the different elements within the text. Their work is identified in the accompanying captions.

Thanks to my son Daniel for his invaluable help in creating the lighting plans for the original manuscript. I never cease to marvel at how accomplished my children are when it comes to computers. I have often been complimented for my apparent never-ending patience, but Daniel showed some considerable patience of his own when creating what was needed to illustrate my instructional manual.

I must also thank Burrell Colour, my lab and partner in the growth of my business, for their efficient and rapid response to my needs. I have always said that my camera is my right hand and my lab is my left; one does not work well without the other—metaphorical perhaps, but true nonetheless.

Thanks too to Tom Waltz and F. J. Westcott for providing photographs of the lighting modifiers described in these pages. While Westcott is not the only producer of quality lighting modifiers, I find myself the proud owner and user of many of their products.

Thanks too to Kerry Firstenberger, my second studio photographer, whose ideas have enhanced much of what we have done during the five or more years she has been with the studio. She has a talented eye and is sure to develop into an outstanding photographer in her own right.

FOREWORD BY BILL HURTER

I have known Norman Phillips since I first came to work at WPPI (Wedding and Portrait Photographers International). Norman's reputation as a portraitist is considerable. He has won awards that are too numerous to mention—with one notable exception. In 2000, he was awarded WPPI's Accolade of Lifetime Photographic Excellence, an award that goes to only the best of the best in the world of wedding and portrait photography.

Beyond his numerous awards, Norman is both an excellent practitioner and teacher. I guess the two go hand in hand. His knowledge extends way beyond the fundamental aspects of good lighting and posing into a realm that could only be termed "experimental." His methods of posing are classical, yet his lighting techniques are innovative and unique. The blend of these two mind-sets produces an uncharacteristic freshness in his images and in his technique.

Norman is a fine teacher. I have witnessed him hold photographers spellbound with his explanations and insights. Nowhere will his teaching skills be more evident than in the pages of this book. A few weeks ago Norman asked me to take a look at the manuscript and, like any really good book, I became absorbed in the content. Having studied portraiture at the Brooks Institute, the terms and techniques are not unfamiliar to me. Yet in these pages I continually found fresh ways to look at high key lighting.

A photography book's worth is measured in the reader's ability to find information he or she will incorporate into a work regime. Even if only one useful tip or technique is found, the book should be looked at as successful. From this book, I would bet that readers will come away with literally dozens of useful techniques that will find their way into these photographers' everyday arsenal of photographic techniques.

Bill Hurter, Editor
Rangefinder *magazine*
Santa Monica, CA

Introduction

WHEN REFERRING TO "KEY," PHOTOGRAPHERS ARE describing the overall tonal range in which the photograph is created. This includes not only the background but also any props and clothing. To some, this may be a little controversial—most think of key as being exclusively based on the tone of the background. If that were strictly true, then we would need to define many more than three keys.

When we refer to *low key*, we are describing an image that has been created primarily with a dark background and that, overall, has more dark than light tones. When we refer to *high key*, we are describing an image that has been created primarily with a white or bright background and that overall has a bright or light tonal range. Obviously, when we refer to *middle key*, we are describing an image with a tonal range approximately midway between low and high key.

Unfortunately, both professionals and those aspiring to professionalism in portraiture often fail to consider the value of creating images in a controlled key. Because of this, many portraits fall short of their potential.

A common problem is that the three basic keys are incorporated in the same image. Such clashing keys essentially break down the composition of the portrait. When multiple keys (high, middle and/or low) appear in the same image, we cause the viewer's eyes to wander around the compo-

Both professionals and those aspiring to professionalism in portraiture often fail to consider the value of creating images in a controlled key.

sition and away from the point of focus. When significantly deeper or lighter tonal areas appear in a background, they draw attention away from the subject. As a result, the essence of the portrait is diminished. To be successful, a portrait must have a message that can be read easily. Mixing keys, or not properly defining the key we are working in, only serves to confuse the message.

The aim of a portrait should be to draw the viewer's eye to the central point of focus—the subject or subjects. When the key is not properly controlled, the viewer is challenged. Using more than one key in a portrait does not allow for good composition, except when deliberately used to create dramatic impact (something that is rarely accomplished, and then only by a master of composition). Controlling the key in which we create our images is one of the most important elements of composition. In professional print competition, judges frequently refer to these errors—making this a valuable lesson for portraitists to learn.

► BACKGROUND SELECTION

A portrait in which the subject has become secondary to the background is generally the result of a failure to correctly visualize and plan the image before exposure. A portrait is a message and a story about the subject or subjects. In any key, the choice of a background should be based on how it will enhance the message, not how it will show off your studio's latest backdrop purchase. You can see the results of "showing off" in many catalogs that advertise backgrounds for sale. These often feature bizarre compositions of subjects presented against ill-chosen backgrounds. This reinforces the fact that the most successful background selections support and enhance the subject and never detract from the purpose of the portrait.

► LIGHTING CONTROL

Balance and control of lighting in the selected key makes a significant difference in the quality of the final portrait. Equally, exposure of the negative material (or digital capture device) is an important factor in determining whether the selected key will be successful or will fail to produce an appealing quality. Also critical is the control of our lighting to ensure that it is compatible with both the subject and the selected key. Determining the appropriate lighting pattern is critical to successful portraiture in any key, and has to be predicated by our vision of the finished portrait.

If we decide that high key is the most appropriate, we need to take steps to keep it properly under control. High key lighting frequently causes problems for photographers. This is especially true in the camera room, because producing a clean white background (when it is desired) requires a lot of light. This can be difficult to control as its scatters and spills over the subject—causing lens flare and washed-out skin tones. It can also yield unflattering, even ugly light patterns, such as hot spots, that retouching will not cure. Many photographers also have trouble producing a clean white foreground. We will discuss these issues and present a number of solutions. We will discuss lighting techniques for different ratios that are designed to produce many different impressions of our subjects and the equipment that is most effective in producing them.

► DIFFERENT APPROACHES

I have heard it said that there are as many ways of producing a given result as there are photographers. While there is much truth to this notion, by using this book as a manual for high key portraiture, readers will be able to determine a useful direction. By making modifications to this, they can develop their personal style.

1. Identifying High Key

Ｈ IGH KEY IS THE TERM USED TO DESCRIBE PHOTOGRAPHS with white or bright backgrounds, and usually with bright lighting situations that render subjects in a light tone similar to that of the background. The ultimate high

key portrait is one in which the background is a clean white and the subjects are also attired in white. The family group photographed by Kim and Peggy Warmolts beautifully illustrates this style (PLATE 1).

► HIGH, MIDDLE AND LOW KEY
High key lends itself to a wide range of interpretations in which we can present our subjects wearing various clothing and against backgrounds that are somewhat more subdued and less than pure white. In fact, high key exists wherever the predominant tones in the image are somewhat brighter than the middle key.

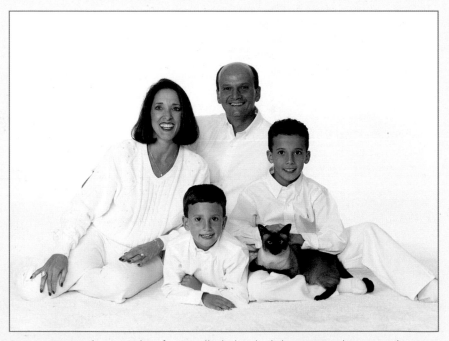

PLATE 1: A superb example of controlled ultra-high key. Note that, in in this portrait with a 2.5:1 ratio and the family attired in white, there is still separation from the high key background. (Photograph: Kim and Peggy Warmolts)

PLATE 2: In this excellent example of low-key portraiture with a 3:1 ratio, you can see the dramatic difference between low and high key images. (Photograph: Jeff Lubin)

PLATE 3: This fine example of a middle key portrait shows the difference between middle and high key. Note the balance between the background and the skin tones that holds middle key, despite the fact that the subject is in black. (Photograph: Jeff Lubin)

When we place Kim and Peggy's high key portrait next to Jeff Lubin's low key family portrait (PLATE 2) the difference is quite stunning. Both portraits are excellent examples of controlled lighting in a selected key. These two portraits clearly establish the contrast between high and low key.

Jeff Lubin's portrait of the woman in a hat (PLATE 3) rounds out these examples with a classical example of controlled middle key. The tonal range between the skin and the background are high-ly complementary and, despite the fact that the subject is clothed in black, middle key is retained. Identifying a key is largely a matter of averaging the overall brightness or lack of it and deciding where the median value falls.

► MULTIPLE KEYS

As noted in the introduction, with careful composition, images can also be created in multiple keys. In my image of a bride on the beach (PLATE 4), WE have a prime example of all three keys appear-ing in the same image: high key at the top of the image, middle key in the center third, and low key in the bottom third. In chapter 15, this same image is presented in a different form to demonstrate enhanced composition.

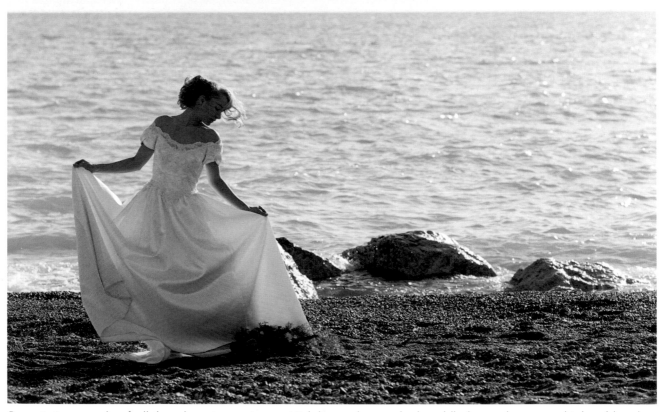

PLATE 4: An example of all three keys in one image. High key in the top third, middle key in the center third and low key in the bottom third.

2. Basic High Key in the Camera Room

IN THIS CHAPTER YOU WILL LEARN THE ELEMENTS THAT MAKE up a high key setup in the studio. Our discussion will begin with background design, then move on to lighting setups, light modifiers and lighting the zones around the subject.

In the camera room, a basic system for high key portraiture requires a white background.

► BACKGROUND DESIGN

In the camera room, a basic system for high key portraiture requires a white background. This may be paper or it may be built of drywall, hardboard or plywood. Typically, it will be a minimum of 9' wide and have a 9' apron that extends across the floor from the background wall toward the camera position.

Because it prevents you from placing the subject at the correct distance from the background, it is very difficult to produce effective high key results when the apron is less than 9' wide. Without enough separation between the subject and the background, it is difficult to create lighting that covers the background evenly but does not flood the subject area. If the subject is too close to the background, there will be too much light reflecting off the background onto the subject. This will have an adverse effect on the lighting of the subject, either causing the subject to appear washed out or resulting in strong side or top lighting that is out of character with the desired lighting pattern. This can break down the modeling or sculpturing of the subject and prevent us from separating the subject from the background. Typically, the subject-to-background distance should be between 4' and 6' (and never less than 3').

Background Zone
(3 feet)

Shooting Zone
(4 feet)

Foreground Zone
(2 feet)

DIAGRAM 1: The three-zone system.

This 9' apron provides a distinct background zone, a shooting zone and a foreground. It allows for proper subject-to-background separation, about a 4' shooting zone (permitting some depth within which to work with our subjects) and an adequate foreground (about 2'). If these are not balanced, they will not produce the desired effect.

If the background is close (3' or less) to the walls on either side of it, it is recommended that the walls be painted gray so as to prevent light from scattering onto the subject. White walls at the side of the sweep will reflect light from the background and bounce it onto the subject.

The above camera room plan is an excellent starting point for high key (DIAGRAM 1). You will see that there is a 9' apron and that the three zones—background, shooting and foreground—are clearly identified. If you are blessed with more space, then you can go wider than 9' and use a proportionately longer apron. This will enable you to create bigger sets and handle larger groups. A basic 9' sweep is described here because background paper rolls are available in 9' widths and 30' lengths. They are also available in 12' widths for those who have more space to use.

PLATE 5 (FACING PAGE): This is a beautiful example of controlled high key with a tinted backdrop. The rendering of the whites and skin tones is superbly handled, and the softening at the edges of the image adds to its charm. (Photograph: Kim and Peggy Warmolts)

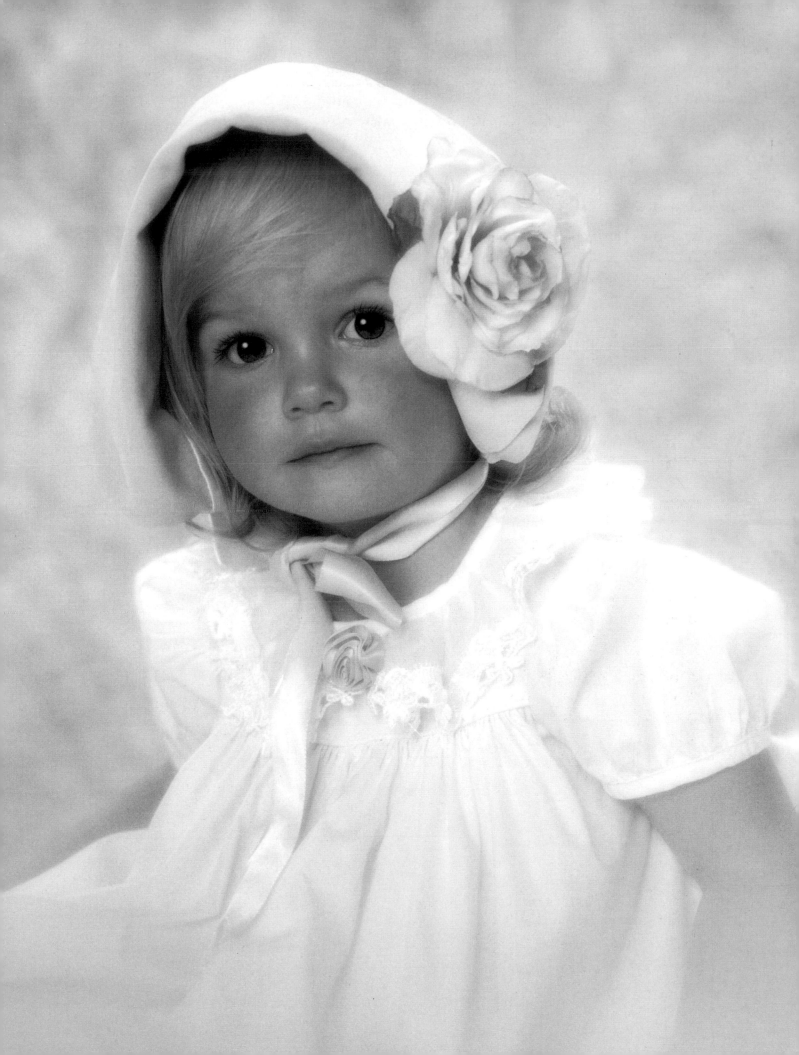

These papers are available in soft white and super white.(Soft white is preferred by most portrait photographers; super white has a colder look that is more appropriate for commercial subjects.) Although a 9' wide backdrop is described, if you have the space, a 12' one is recommended. This will allow you to work with larger sets, or groups placed closer to the front of the shooting zone. Remember, the further forward the subject, the smaller the background will appear. Because of this, a wider background wall is always an advantage.

► LIGHTING SETUP

Lighting the three zones (foreground, subject and background) is the next step.

Background Lights. First, the lighting should be set to evenly illuminate the background. Failing to do so may result in a patchy look on the background, or unevenly lit patterns of whites and grays, which will not look good.

The simplest way to light the background is to place a lighting unit at each side of the background, as shown in diagram 2. These must be positioned so that neither intrudes into the camera viewfinder. The lighting units may be on light stands, on wall booms or on a ceiling track system. Wall booms may be the best option in spaces that are less than 10' wide, since light stands will intrude into the background area and reduce the amount of shoot-

ing space. Using booms, you can place your lighting units out of the view of the camera and work free of the stands and cables that can become a nuisance—especially when photographing small children who may be attracted to them. Additionally, using booms will prevent your subjects from accidentally moving your lights.

A ceiling-mounted rail system is the ideal, but only works when you have a ceiling height of at least 10'. Installing a ceiling system is a major operation, and although it is relatively expensive, it is also highly desirable.

With the lighting units in place, basic reflectors should be attached to the heads. These will allow you to use attachments like barn doors or gobos that, with proper adjustments, will control the spread of light onto the background. Diagram 2 shows how these can be adjusted for light control.

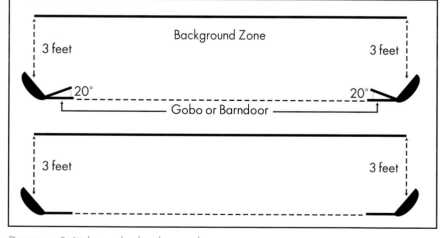

DIAGRAM 2: Lighting the background zone..

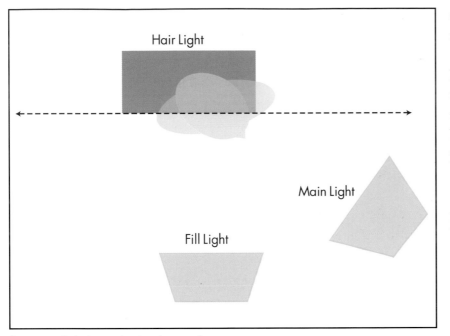

Hair Light

Main Light

Fill Light

DIAGRAM 3: Lighting the background zone..

The light heads should also be carefully directed and metered to ensure they are producing as even a lighting pattern as possible. By ensuring that these lights are metered to *at least* one full stop greater than the light metered for the subject, you can consistently create a background that appears as clean white. If you are exposing the subject at f-8, for example, the light directed to the background should be between f-11 and f-16. It is generally recommended that 1–1$^1/_2$ stops more light falls on the background than on the subject.

Main Light. Next, a lighting unit is needed as a main light. As a starting point, place this at the front edge of the white apron, and at approximately a 45-degree angle from the subject. Set this light to read f-8 at the subject.

In addition to lighting the subject, this main light is also required to light the foreground and render it clean white (avoiding a gray area at the front and on the floor under the subject). Because of this, the main light will also be aimed at an angle sufficient to properly illuminate the foreground. As the foreground is closer to the camera than the subject, the light should produce a meter reading of between f-8 and f-11 in this area. This will ensure that the foreground will be a clean white. At the same time, because the light on the subject is calculated at f-8 the area below the subject will have enough shadowing for him/her to appear to have a base, and not to be floating in space.

Fill Light. Finally, in this minimal setup, a fill light is required to control the light ratio. This light should be placed as close to the camera as possible and (with the main light at f-8 on the subject) should be set to meter f-5.6 at the subject. This will pro-

duce the most commonly used ratio (3:1).

Hair Light. In most high key lighting sets, hair lights are not needed. In diagram 3 a hair light is indicated, but this would probably be required only if the subject was placed at the very front of the shooting zone. In that position, a subject with dark hair may not pick up adequate lighting in the hair, necessitating a hair light. Note that the hair light is placed so that it does not spill onto the front of the head where it would either interfere with the lighting pattern or create a bright area on the forehead.

▶ LIGHT MODIFIERS

To provide the type of lighting that is best suited for portraiture, light units require modifiers. The modifiers you select will depend on how you want your subject to be represented. Most light heads are supplied with at least basic reflectors and accept the numerous accessories available on the market. Most manufacturers of light heads also produce modifiers such as the ones discussed here. When ordering any modifier, be sure to advise the supplier of the make of the light head, as you may need a special adapter. Diagram 3 shows how flags or gobos may be adjusted to control the spread of light.

Soft Light. For high key portraits of children, and most women and family groups, the ideal modifier will produce a slightly softened light quality.

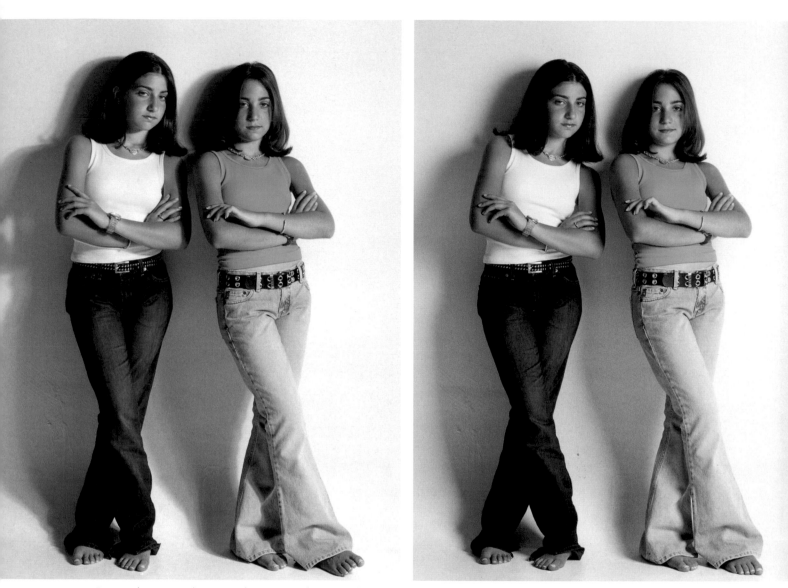

PLATE 6 (ABOVE, LEFT), PLATE 7 (ABOVE RIGHT), PLATE 8 (FACING PAGE, LEFT), PLATE 9 (FACING PAGE, RIGHT): These four images show a sequence in which the lighting and the angle are changed to first produce a chiseled look (PLATE 6), a gentler look (PLATE 7), a soft look (PLATE 8) and a flat look (PLATE 9).

This can be achieved with umbrellas or soft boxes. The aim is to produce a quality of light that is neither harsh nor too soft—light that is flattering, but retains the vibrancy in the highlights that creates a lifelike appearance. To achieve this, you may choose to use a soft box fitted with a single scrim (possibly with louvers) at the front, or a silver/white umbrella. The umbrella may even be a zebra style, which combines alternating panels of silver and white material.

With such a setup, the background lights should be modified only by the silver reflectors, gobos, barn doors and/or blockers, which are best suited to enable them to evenly illuminate the background.

▶ LIGHTING THE ZONES
When the basic lighting setup is in place, identify the background, subject and foreground zones on the set. With the lighting switched on, you will see that the recommended 3' background zone is clearly brighter to the eye than the subject zone or the foreground. With this in mind, you can place your subjects at a distance from the background that will prevent light from the background falling onto them (as discussed on page 19). Ideally, the subjects should be placed at the front of the subject

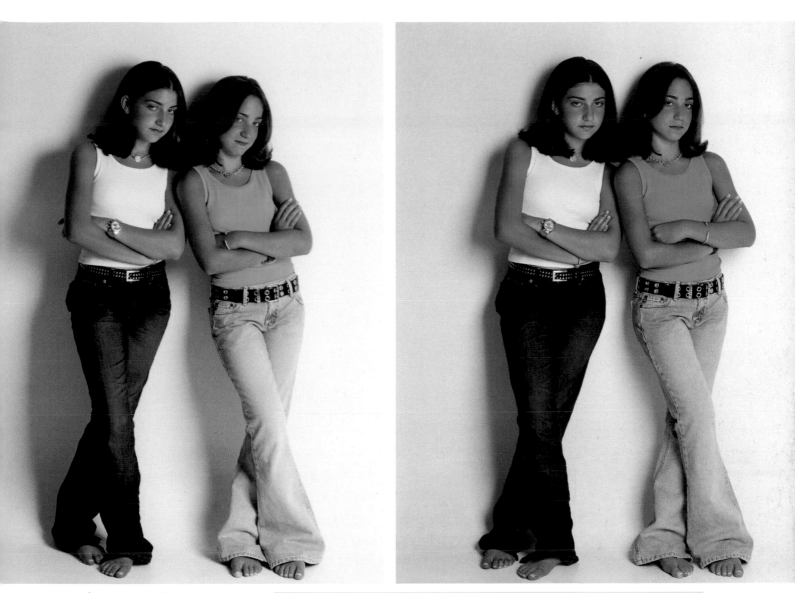

zone (3' from the front edge of the sweep), or at least no deeper than 4.5' from the front edge of the foreground zone. You'll note that, with (in most cases) very minor changes in the key light position, this set also provides you with the opportunity to photograph your ever-moving younger subjects in a zone that is about 5' wide and 1.5' deep.

HINTS AND TIPS
Although it is recommended that subjects not be positioned close to the background with the basic high key set, you may create some very interesting and attractive images by using the white background without the background lighting. To see how this would appear, examine the above series of portraits of two young ladies (PLATES 6–9). These amply illustrate the difference between the chiseled, gentler, soft and flat looks that we will examine in later chapters.

3. Equipment

THE BASIC NEEDS FOR THE HIGH KEY SETUP DISCUSSED IN chapter 2 are four light heads and four sturdy light stands (unless you are going to suspend the units from the ceiling). For each unit, you will need a reflector that accepts the light modifiers you intend to use. Remote triggering is also recommended.

► LIGHTING UNITS

There are basically two common types of studio lighting systems. These are: mono heads (lights that are independently powered), and asymmetric (systems in which all the light heads are powered by a central power supply). When photographing children, especially the younger ones, it is best to reduce the number of cables and wires on your set as much as possible. With mono heads, you reduce the need to run wires, since you can access your power outlets independently and keep the cables well away from curious, free-spirited little people.

Mono heads can be purchased at a wide range of prices, from inexpensive to premium. When purchasing, take into account your full range of needs and look for heads with a range of output that meets your minimum needs *as well as* your potential maximum needs with modifiers (which may require a greater power output to produce a given f-stop). Units that produce only 250 watt-seconds, while relatively inexpensive, will be of only limited use in many situations. For your main light, look for units

Take into account your full range of needs and look for heads with a range of output that meets your minimum needs as well as your potential maximum needs.l

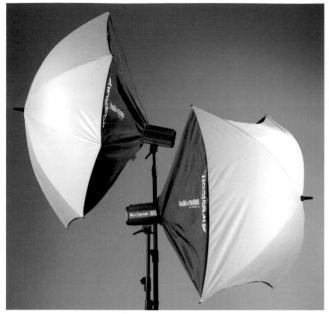

PLATE 10: Side view of the unique Halo Round and Square Mono modifiers.

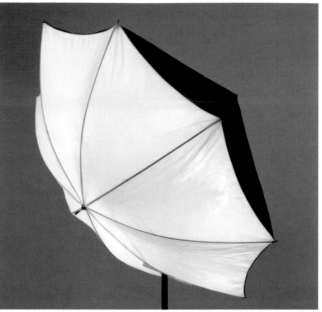

PLATE 11: Front view of Halo modifier.

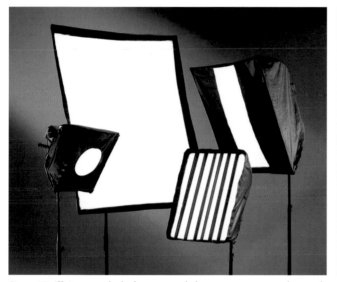

PLATE 12: Illustrates light boxes with louvers, strip- and round-modifying accessories.

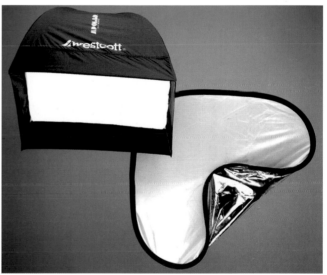

PLATE 13: Illustrates a recessed light box. Recessing permits greater control of light direction. Also illustrates collapsible reflector with silver on one side and white on the other.

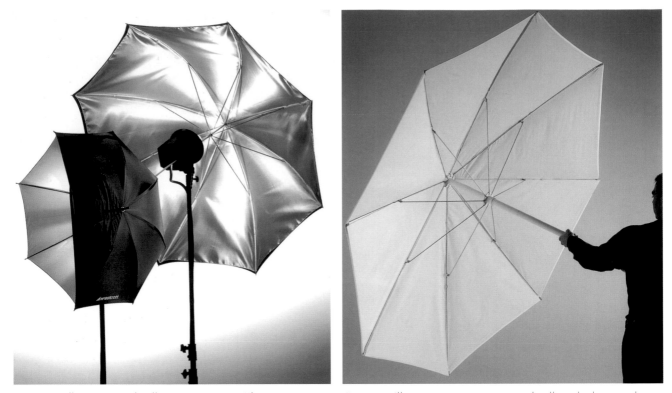

PLATE 14: Illustrates umbrella construction. These are satin and are available in white, silver or a combination of both colors.

PLATE 15: Illustrates an oversize umbrella which provides a large soft light source.

that offer variable power settings, with a minimum of 250 watt-seconds and up to 750 watt-seconds of power. Additionally, it is recommended that the internal modeling light in the mono head be correlated to current power setting, and also be available at full power.

There is one important caveat to this: when inquiring about the watt-seconds available, you should also ask for the guide number at the unit's lowest power setting. A guide number is more reliable than the advertised watt-seconds, since manufacturers use different methods of measuring power output. Divide the guide number by the distance from the light source to the subject to get an f-stop. The standard is to divide by ten (10'), which will provide the appropriate f-stop for a flash-to-subject distance of 10'. For example, if the guide number at 100 ISO is 160, at 10' (and without a light modifier) you can use f-16.

The fill light can be a unit similar to your main light. This light does not need to be as powerful as your key light as it will be set to at least one f-stop less output. Because of this, you may purchase a unit that has a lower power output.

► MAIN LIGHT MODIFIERS

Umbrellas. The modifier of choice for your main light should be one that produces a semi-specular effect. An umbrella that incorporates both soft white and

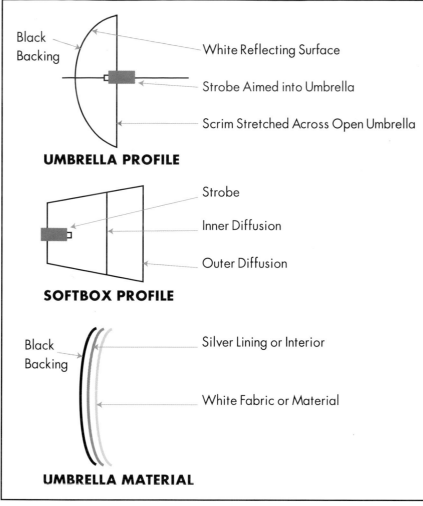

UMBRELLA PROFILE

- Black Backing
- White Reflecting Surface
- Strobe Aimed into Umbrella
- Scrim Stretched Across Open Umbrella

SOFTBOX PROFILE

- Strobe
- Inner Diffusion
- Outer Diffusion

UMBRELLA MATERIAL

- Black Backing
- Silver Lining or Interior
- White Fabric or Material

DIAGRAM 4: Explanation of modifiers and their construction.

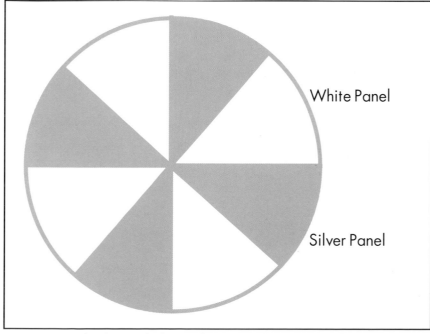

- White Panel
- Silver Panel

DIAGRAM 5: Soft white and silver surfaces combined in an umbrella.

silver surfaces is one choice for achieving this effect. In some cases, this combination may be a soft white fabric over a silver base, while in others it may be a zebra-type arrangement, with alternating panels of silver and white. The latter will produce slightly more specular highlights. Also available and popular are umbrellas with silver interiors that also have a reversed-umbrella front scrim (such as the Westcott Halo and Halo Mono). These are available in a variety of sizes.

Soft Boxes. In a soft box, the equivalent to the aforementioned zebra umbrella is a box with a silver interior and a white scrim in the front. Many soft boxes also include the option to use a second scrim that is positioned between the flash tube and the front scrim. Unless a totally non-specular, extra-soft lighting effect is desired, this is not recommended for high key portraiture.

Most soft boxes are rectangular and, unless used carefully, will produce rectangular catchlights in the eyes—especially in close-up shots. If a soft box is your lighting choice, you should choose a model with a front-end attachment of black material with a circular opening. This will, instead, produce a round catchlight. Since this attachment blocks off a portion of the light, for this to be effective, a much larger box is required to provide adequate coverage for both the subject and the foreground (especially in half-, 3/4- and full-length portraits).

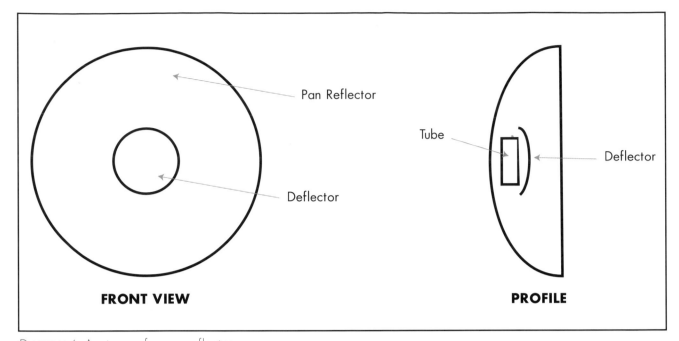

FRONT VIEW **PROFILE**

DIAGRAM 6: Anatomy of a pan reflector.

► FILL LIGHT MODIFIERS

You may choose to bounce your fill light off a rear wall or reflector panel. There are a variety of methods one can use to modify the fill light. These will be referred to in other chapters, as we discuss lighting sets. The important thing is to ensure that you are able to create the desired ratio.

► BACKGROUND LIGHT MODIFIERS

The background lights need reflectors that allow you to adequately illuminate the background zone behind your subjects. First, you must select the correct size reflector. Second, you must choose either gobos or blockers, such as flags or barn doors, to control the spread of light and keep it within the required area.

► REMOTE TRIGGERING

It is also recommended that remote triggering be used. This eliminates the clutter of cables that can get underfoot and cause subjects, especially younger ones, to trip and fall. Remote systems may be either radio or infrared. Both systems include a transmitter attached to the camera and a receiver that is plugged into the light head via a jack.

4. Metering Your High Key Set

I N HIGH KEY PORTRAITURE, EXPOSURE IS CRITICAL IN WAYS that are a little different from each of the other keys we may work in. Underexposure in high key will make our portraits appear lifeless and lacking in skin tone values. It will

cause whites to appear gray. Dark-haired subjects will have virtually no detail, and fair-haired subjects will appear to have much darker hair than they actually do. The reason for this is that, in a high key set, there is a lot more light than in any of the other keys. This requires us to ensure that there is a correct balance between the lighting on the subject and the lighting on the background.

► LENS APERTURE

Generally, portraits should not be exposed at lens apertures smaller than f-8 to f-11—unless they are environmental and it is necessary to show a large area of background in sharp focus, or if you are photographing a large group and need greater depth of field to render your subjects sharply. In your camera room, f-stops between f-5.6 and f-8.5 are more than adequate to keep subjects in ideal focus.

► EXPOSURE

Overexposure. Tests will demonstrate that, when you wish to expose at f-8, you will be well served to overexpose the negative by half a stop. This will provide you with a negative with adequate fidelity, and allow you to produce prints that have clean skin tones. In high key photography, there is much more tolerance for overexposure—up to one full f-stop. It

This will provide you with a negative with adequate fidelity, and allow you to produce prints that have clean skin tones.

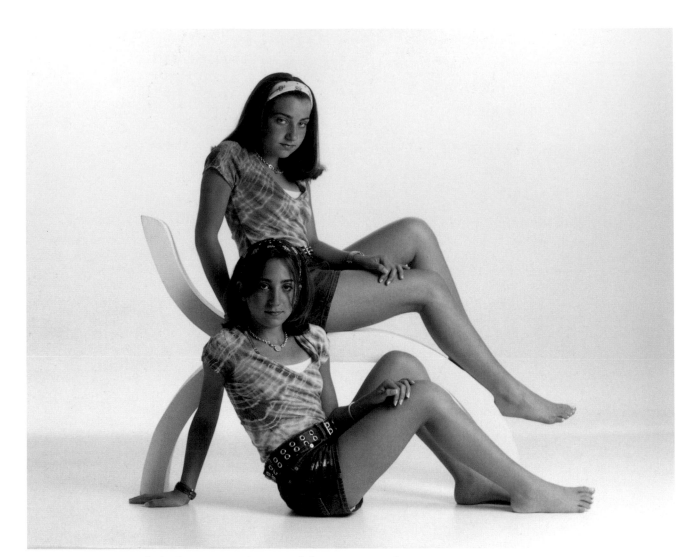

is not recommended, however, that you overexpose by more than one f-stop, as you will oversaturate your negatives, lose detail in your skin tones and increase potential graininess (making it difficult to produce good prints). It is advisable to work with your printer and evaluate densitometer readings of the skin tones on your negatives. These will provide you with the information needed to decide how much more or less light is required to produce the kind of prints you desire.

Underexposure. When shooting high key portraits, you must be careful not to underexpose your negatives. This is a common error. When you underexpose in high key settings, your images lack vitality, look drab and are only borderline high key. Even in your color work, you will see a predominance of gray tones.

► METER SELECTION

To obtain an accurate exposure reading, you need an exposure meter. Most professional light meters have the ability to take flash readings by both the incident and reflective methods, and over an ISO range of 50 to 5000.

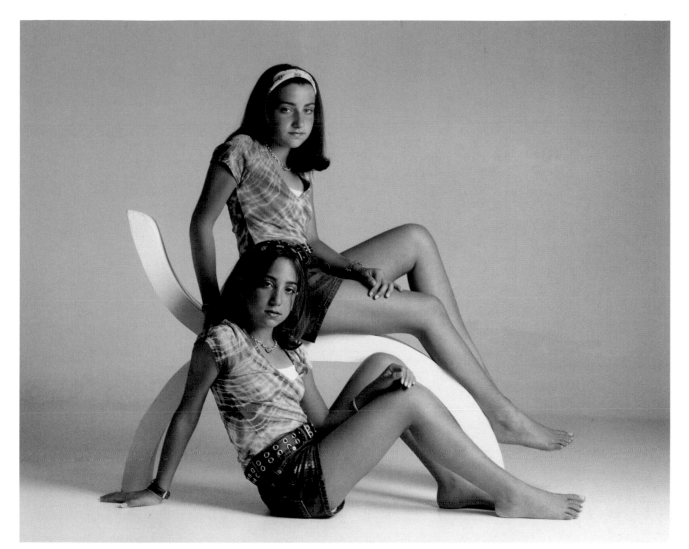

PLATE 16 (FACING PAGE), PLATE 17 (ABOVE): These two images show how easy it is to convert a high key portrait into a middle key one by eliminating the background lighting when the subjects are near the front of the shooting zone.

These meters have a curved white cone that measures the light for incident light readings (which is what you will be using for most of the readings you take). The cone can be removed so reflective readings can be taken (used for metering the background). The best meters for our use are those that also permit us to recess the cone so that its sides will not be struck by extraneous light. When light from the sides/above is allowed to strike the cone, the readings will be inaccurate.

Incident readings are taken by aiming the cone of the meter at the light source that is directed toward the subject. Reflective readings require you to aim the meter without the cone so that it records the light reflected by the subject. Some photographers use this method to obtain a hyper-accurate skin tone reading. Indeed, there are a number of methods used by photographers to acquire accurate exposure readings. In the end, it does not matter what method you use, as long as you consistently obtain the desired results. The following sections describe one method that has been shown to be reliable.

Exposure Compensation. Most photographers recognize that our exposure meter is calibrated against an 18 percent gray and readings are based on the reflectance of 18 percent gray. (18 percent gray is also called middle gray. Cards of this color [called gray cards] are available at photo supply stores as a resource for exposure calculations.) This middle gray is the averaged reading that is the basis for all exposure calculations. Keep in mind, however, that 18 percent gray is not high key, it is low key. Because of this, high key images require significantly more exposure than an averaged reading that is based on light reflected from a gray card. In fact, to render a gray card in a high key tone, you need at least two f-stops more exposure than you need to accurately represent it as 18 percent gray. In other words, to make an 18 percent gray card appear high key, you need to overexpose it by at least two f-stops.

► METERING

THE BACKGROUND LIGHTS

Many photographers experience difficulty when trying to produce a white background in their high key portraits and often produce, instead, images that have off-white, gray or muddy-colored backgrounds—especially at the line that separates the background from the floor. Even more have difficulty in preventing the foreground from rendering as muddy gray or off-white. Consequently, their images are compromised

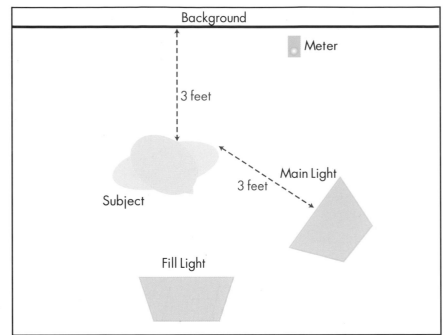

DIAGRAM 7: Position of meter to measure background lighting.

and, while they do not fall into middle key, they do not have a clean appearance. The problem generally results from too little light being directed toward the background.

Background Color. For high key portraits in a studio situation, you would normally use either a clean white or light-colored background. When the background is not bright white (for example, when using the muted pastel backdrops that are very popular with some of the leading portraitists), exposure compensation skills become very important.

The photographs of two girls shown on pages 28–29 demonstrate this concept. The high key effect, with two f-stops more light on the background than on the subject (PLATE 16), is eliminated when the background is not overexposed (PLATE 17). As a result, the image falls into middle key.

This means that, if you are using 200 watt-seconds of power to represent an 18 percent gray background accurately, you will need 600 watt-seconds for it to be rendered as a high key tone. This will cause the gray card to appear as a pale gray, approximately halfway between the 18 percent gray card and the white of a clean white background sweep (at the dividing line between middle and high key. (At the same time, however, you need to ensure that you do not overexpose the subject by the same degree.)

Practical Example. Let's assume that your desired lens setting is going to be f-8. This means that, to make the background go white, you need to create a light meter reading between f-11 and f-16 on your white background. Turn on *only* the background lights for this reading. With the lights on, aim the meter's cone at

the light source and take a reading. You can take these readings using a remote control to fire the flash, or by what is termed "cord in," which means you will have a PC cord connected to both the light and the meter.

Take these readings across the width of the background, keeping in mind the target minimum exposure of between f-11 and f-16. Adjust the power until it produces the desired output. Depending on the system used there may be a slight variation of up to ⅓ f-stop in these readings. Take this variation into account when taking your readings and bear in mind that a bit too much light is fine, but too little light (meaning some areas will be gray instead of white) is not desirable. Diagram 7 indicates the position of the meter to measure the background lighting.

If you have a meter that provides spot metering, you can use the spot-metering mode to meter the background from the camera position. In this mode, the meter should be aimed at the background. If both readings fall within ⅓–½ stop of each other, you have verified a reliable reading.

Subject-to-Background Light Ratio. The ratio of light between the subject and the background should never be more than 3:1 (see chapter 5 for information on calculating light ratios). This means that the difference between the light on the background and the light on the subject should not be greater than one f-stop. In extremely bright situations you may extend this to 3.5:1. This means that when an exposure of the subject is at f-8, the exposure of the background should not be less than f-4.5 (between f-5.6 and f-4), or 1½ f-stops. In this case, a meter reading of f-4 at the background would indicate that there were two stops less light on the background than on the subject, a ratio of 4:1. For this reason, the portrait would actually fall very close to the margin between middle and low key.

▶ METERING THE MAIN LIGHT

To meter the main light, the background lights should be turned off and the meter set in the incident mode (with the cone in a recessed position). Then, turn on the main light and, working from the subject position, aim the meter at the key light. Remember, you are going to shoot with your lens set at f-8. In most high key lighting setups, you will need an additional light output of ½ stop. This means that the recommended reading from the position will be f-8.5. This extra ½ stop of exposure will produce a more vibrant skin tone and retain the overall high key look. Again, remember that this is a starting point and tests should be made until you obtain the effect you desire.

▶ METERING THE FOREGROUND

It is recommended that a meter reading be taken of the foreground in front of the subject. This is to ensure that you do not create muddy or gray areas in

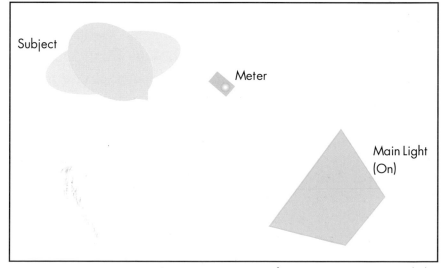

Subject

Meter

Main Light
(On)

DIAGRAM 8: Position of meter to measure main light.

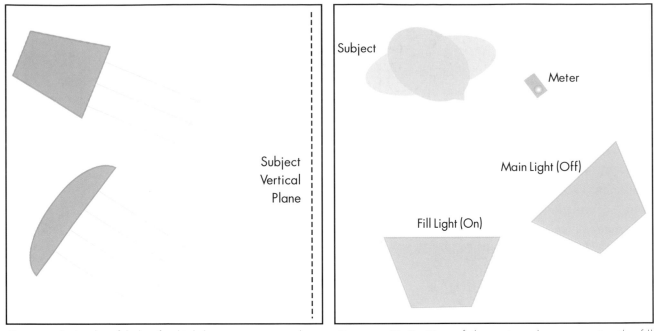

DIAGRAM 9: Angle of lights for high key to ensure a clean white foreground.

DIAGRAM 10: Position of the meter when measuring the fill light.

front of or below the subject. This reading may be taken in either the incident or reflective metering mode. As previously noted, this should result in a reading between f-8 and f-11. For this reading, the meter should be placed in virtually the same position as for the main light reading, but aimed up from the floor in front of the subject.

In diagram 9 you will note the recommended angle of the lights as they relate to the subject for a clean white foreground.

► METERING THE FILL LIGHT

To meter the fill light, turn off all the lights, except for the fill light. Working from the subject position with your meter in the incident mode, aim the meter at the main light. Take readings and adjust the power output until a reading of between f-5.6 and f-6.3 is

obtained. With the main light at f-8.5, this will provide a ratio of 3:1. Depending on your preference, this reading may be modified to create another ratio. It is strongly advised that when photographing children and most women in high key, however, the ratio does not exceed 3.5:1. Diagram 10 indicates the position of the meter when measuring the fill light.

► TOTAL SCENE METERING

A meter reading of the total scene may be taken to see if there is an excessive amount of extraneous light filling the scene (this could cause flare and reduce the light pattern on the subject). This reading should be taken from the camera position with all the lights on, as if you were actually photographing the subject. If this reading exceeds f-11.5, there is probably a lot of extraneous light being

reflected off walls other than the background. If this is the case, it is recommended that the side walls in the camera room be subdued so that they do not reflect so much light. Placing black (or at least 18 percent gray) panels against the walls ought to achieve this.

Your lighting setup is now complete. This is an excellent starting point and has proven to be very successful for achieving sparkling portraits—especially of children, who tend to move around. This same basic setup is ideal for larger groups, as it provides both width and adequate depth to cover groups that may be up to 30" from front to back. As time goes by, you may decide to modify this setup in order to achieve even more varied results.

5. Light Ratios

LIGHT RATIOS DESCRIBE THE DIFFERENCE BETWEEN THE amount of light that falls on the highlight areas and the amount of light that falls on the shadow areas of our subjects. These are expressed as proportions, like 3:1 (three times more light on the highlight areas than on the shadow areas) or 2:1 (two times more light on the highlight areas than on the shadow areas). This lighting difference affects contrast and the rendition of detail. For instance, a 3:1 ratio will show substantially more detail in the shadow side of the portrait than will a 4:1 ratio. Basically, the higher the ratio, the greater the contrast between highlight and shadow will be. Darker shadows mean less detail in the shadow side of the portrait.

In high key portraiture, the subject is generally presented in a light ratio from 2:1 to 3:1. There are some situations in which the ratio may be greater, but these must be carefully selected to prevent the subject and the background from appearing out of character with each other. Fashion photographers and some wedding photographers who work in the photojournalist style frequently use high light ratios in high key situations. When working with children, one may sometimes want to use a high ratio to create a special effect. However, the vast majority of parents prefer images of their children that have a lower ratio, since this yields a warmer and more cuddly image. Most portraits of women will also be more flattering when a lower

> The higher the ratio, the greater the contrast between highlight and shadow will be. Darker shadows mean less detail in the shadow side of the portrait.

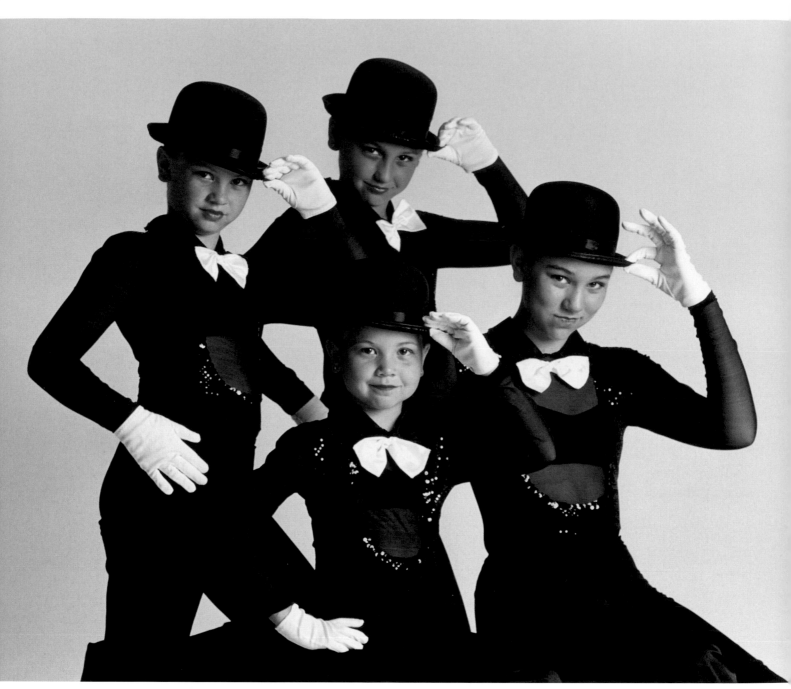

PLATE 17: You can also use high key to create portraits in which the subject, perhaps in dark clothing, is deliberately shown in stark relief against a white background in order to create a dramatic impact. For this to be successful there must be adequate white or bright background surrounding the subject or it will not represent high key. The portrait shown here is at the cusp of the high key range. With so much black, the high key tonal range is maintained only by the background, white gloves and bow ties. This causes the average of the overall brightness to remain in high key.

ratio is used. Conversely, when photographing men in high key, a larger ratio may be used to create a stronger, more masculine effect. When using a lighting ratio greater than 3:1 it is essential that the background is white or one will lose the balance needed to produce high key.

▶ PARAMETERS

There is a great deal of discussion in portraiture about light ratios. In the minds of many portrait artists, there are very specific parameters—2:1, 3:1, 4:1, etc. However, when we are in control of our lighting and are able to observe its subtleties, we can modify ratios in much smaller increments in order to represent our subjects in the most effective way possible. In this chapter, however, we will be specific and refer to only five ratios. These are 2:1, 2.5:1, 3:1, 3.5:1, and 4:1, as these are the most commonly used and recognizable ratios.

As can be observed in the examples (PLATES 18–22), as you move from the shortest of these ratios (2:1), through to the longest (4:1), the detail on the shadow side of the subject's face (the side opposite the main light) is subtly reduced until there is virtually no detail at all. If you place examples of the shortest and the longest ratios side by side, the difference is dramatic. There may be a good reason for using any one of these ratios; the choice has to be made based on how you wish to represent the subject.

PLATE 18: Face with 2:1 light ratio.

PLATE 19: Face with 2.5:1 light ratio.

PLATE 20: Face with 3:1 light ratio.

PLATE 21: Face with 3.5:1 light ratio.

PLATE 22: Face with 4:1 light ratio.

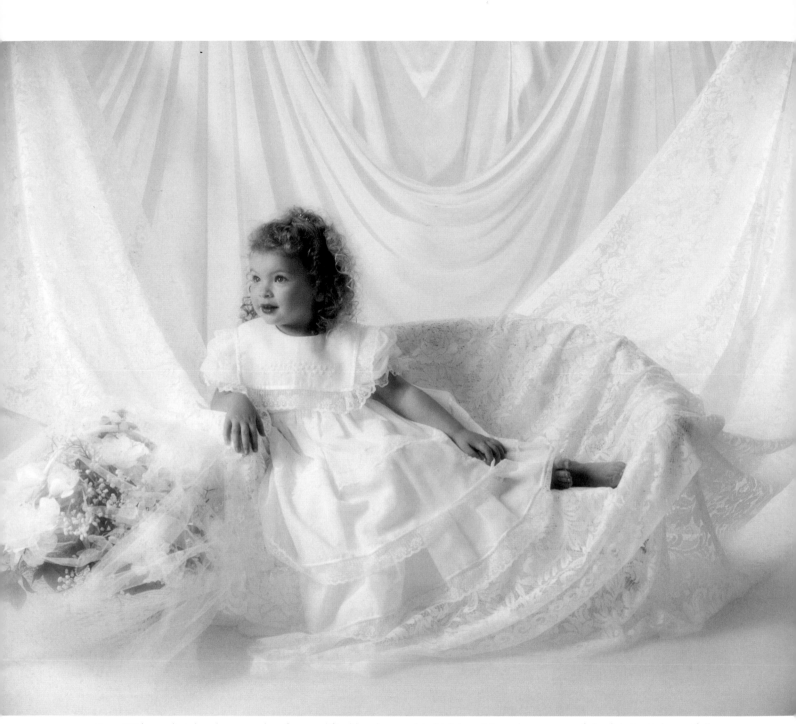

PLATE 23 (ABOVE): A lovely example of a modified background in high key. Note the texture of the fabrics is beautifully represented without detracting from the little subject. The basic 3:1 ratio appears longer because the girl is turned away from the camera. (Photograph: Kim and Peggy Warmolts)

PLATE 24 (FACING PAGE): This portrait of one-week-old twin babies in a basket with flowers was created with overhead lighting. Overhead lighting will normally be relatively flat, so the fabrics used were selected for their ability to reflect back the light, producing lots of clean white highlight.

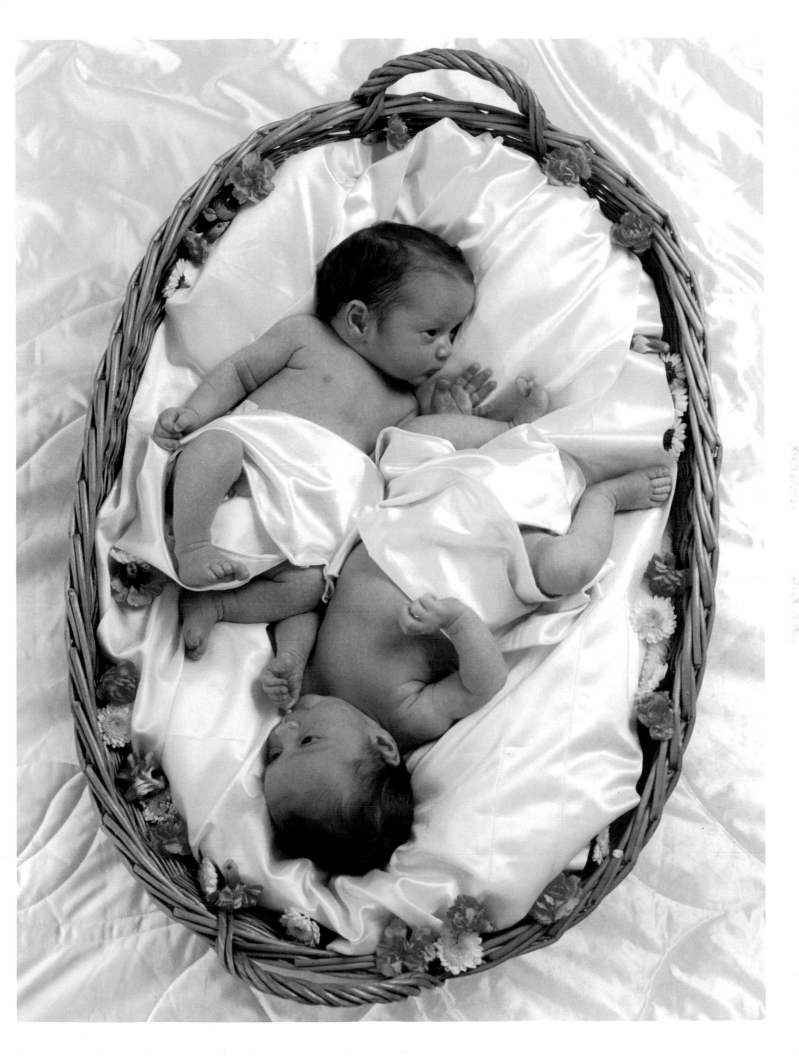

► JUDGING RATIOS

Judging a ratio can be difficult because the human eye adjusts to almost any lighting situation, allowing it to see into shadow areas in ways film is unable to replicate. This is why we use the f-stop ratio system of increasing or decreasing output; these established increments ensure that you can *produce* the ratio without the need to *recognize* it. While this method produces recognizable ratios, it is still recommended that you practice adjusting ratios and learn to see the effects of the lighting prior to exposure.

► SELECTING THE RIGHT LIGHT RATIO

The important thing is to select the ratio that is going to be the most pleasing to the viewer and most suited to your chosen style of portraiture. Each of us will develop a personal style and a sense for the ratio that pleases us most. Once you have established a style, you can build a reputation with it. If you decide to be a fashion portraitist, then the longer ratios will be the ones that you will use. If you aim to be successful in children's portraiture, then you are more likely to work with the shorter ratios.

► CREATING THE DESIRED LIGHT RATIO

Ratios are controlled by three factors. The first is the power of the fill light used. The second is the angle of the main light in relation to the subject. The sharper the angle of the key light to the subject, the longer the ratio will be. There is a limit, however, to how sharp the angle may be. If the angle is too sharp then you will essentially have split lighting and the ratio will be lost as there will be no skin tones to see on the shadow side of the face.

The third way to control ratio is by the position of the subject's head. A longer ratio may be created by turning the subject's head slightly away from the the main light. When the head is turned away from the key light to the point just before it would create a split lighting pattern, the shadow side appears significantly darker and the ratio is effectively longer.

► CALCULATING LIGHT RATIOS

A ratio is calculated by measuring the difference in output between the main light(s) and the fill light(s). Each full f-stop equals two units of light. Let's look at a couple of examples.

If the main or key light is set for exposure at f-8 and the fill light is metered at f-5.6, there is a difference of one f-stop, or two units of light. The fill light is always calculated as one unit, and is added to the two units of the key light for a total of three—thus the ratio here is 3:1. If we keep the main light at f-8 but reduce the fill light by ½ stop (to f-4.5), we will have *increased* the ratio by one unit, making it 4:1. This is because the difference between the main light and the fill light is now *three* units of light. Added to the one unit of fill light, this adds up to four, hence 4:1.

A common error photographers make when calculating light ratios is to count a full f-stop as only one unit of light. While this may create an image that is visually acceptable, it is misleading when making calculations for future images. This may lead to portraits that have a serious lack of detail in the shadow side.

► STYLE

The portraits included in this book rarely show ratios shorter than 3:1 or longer than 4:1. This is simply because the images included are those produced by professionals who have created a lucrative market for their work because of a recognizable style—including the lighting styles most portrait buyers prefer. Despite this preference, you will do well to be proficient at creating a full range of light ratios, so that you are able to meet the demands of *all* your clients. You never know when you may be required to produce something more or less dramatic than what you are accustomed to creating. Remember, style is not a matter of repetition of a certain composition or lighting technique. It is about a recognized quality and the expectation of creativity.

PLATE 25: Here is a masterful combination of ultra-soft, almost flat light from the front with a little kicker from the left to produce an enchanting mother and baby portrait with exquisite skin tones. (Photograph: Jeff Lubin)

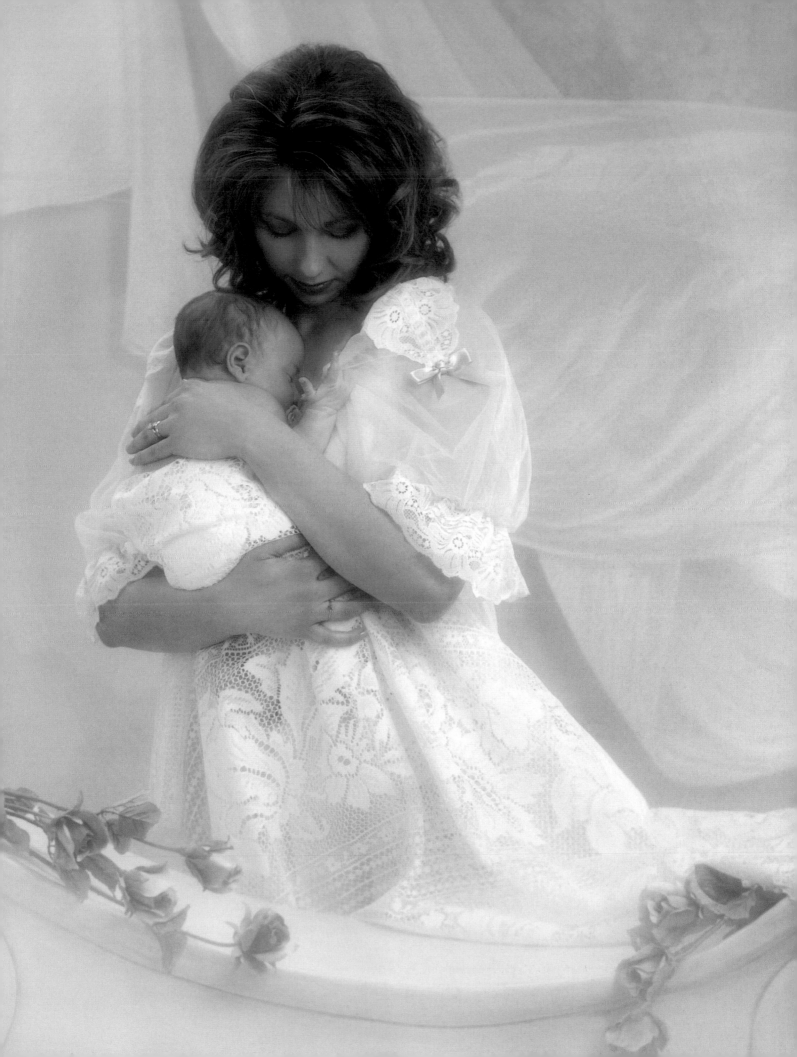

6. The Chiseled Look

I

N CHAPTER 2, WE DISCUSSED SOFTER LIGHTING, WHICH IDEALLY suits women, children and family groups. In this chapter, we will look at a style where we use light to sculpt the subject for a chiseled look. This portrait will have a stronger

contrast between the highlights and the shadows (between 4:1 and 4.5:1), and show the subject with a deeper, more shadowed look. This look is popular when photographing men, because it can be described as "stronger." It can also be used when photographing women, yielding a style similar to that used to photograph movie stars in the 1930s and 1940s. It is a much more dramatic look than the 3:1 or 3.5:1 lighting that is most commonly used on women.

 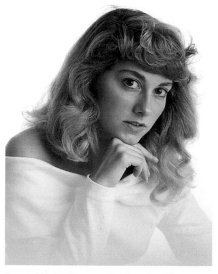

PLATE 26: This is an example of a 4.5:1 ratio.

PLATE 27: This is an example of a 3.5:1 ratio.

► MAIN LIGHT

Modifiers. This type of portrait is going to be lit with a more specular (or harder) quality of light.

This means we need to select a modifier that is less diffused than the one used in our basic set. There are three basic lighting systems that will produce the kind of specular highlights that we are seeking.

The first is a soft box with a silver interior and two optional scrims, one at the front of the box and one that is placed between the front scrim and the light source (the flash tube). With this modifier, we will be using only the scrim that would be placed between the front and the light source. We will not use the front scrim. This arrangement has the effect of first slightly diffusing the light and then picking up specularity from the silver interior. The overall effect of this light on the skin tones produces clean and bright specular highlights, and renders less detail on the shadow area. A second choice would be to use the same box, but without any scrim. This will produce a harder effect than the first option, and will also require a smaller lens aperture at the same distance from the subject.

When using this light, you will need to control its spread. The best way to do this is by narrowing the light source directed at the subject. This may be achieved by attaching panels to the front of the box or by selecting a narrower box. This is often referred to as a strip box, and has an area no more than 12" wide at the front. This type of box is available from a number of suppliers in dimen-

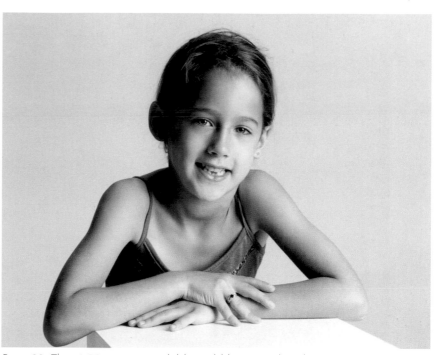

PLATE 28: This 4.5:1 ratio on a child would be considered inappropriate.

sions from 24" x 9" through 72" x 12". This will provide a greater degree of control of the lighting pattern.

The third option for a chiseled effect is to use a pan reflector. A pan reflector is an aluminum or metal dish lighting attachment that produces a fairly specular light. It has a central diffuser that is placed close to the light source. The diffuser is usually silvered or polished aluminum, which reflects the light back into the base of the pan reflector and covers the whole surface of the reflector. When using a pan reflector it is recommended that barn doors be attached in order to control the direction of the light, and prevent unwanted scattered light. However, a pan reflector may not always be adequate for full-length portraits, since they are not normally available in larger sizes.

Placement. The use of harder light sources such as these requires us to pay special attention to the placement of the main light. Remember, compared to softer sources, these lights are very unforgiving.

We must carefully adjust our light so that it illuminates the areas of the face that form the basis of our portrait palette—the forehead, both cheeks, the chin and the nose. The shadow from the nose should not encroach onto the cheek of the shadow side, but create what is referred to as a loop or butterfly pattern. These are both descriptions of light patterns that are flattering to the human face. The loop pattern describes lighting that produces a shadow under the nose that fills the area from the nose to the smile lines of the cheek. The butterfly pattern describes lighting that creates a shadow under the nose that looks a little like a butterfly, and is slightly toward the shadow side of the face.

In many cases, this chiseled setup will have the main light

placed at a sharper angle to the subject than the 45-degree angle in our basic set. Alternately, you can place the main light at 45 degrees and feather it. Feathering is the technique of directing light *across* the face of the subject, as opposed to directing it *straight at* the subject.

▶ FILL LIGHT

Mono Heads. You now need to choose a fill light. In order to maintain balance, you may also wish to harden (make more specular) the fill light. However, this may not be necessary—and it is often more difficult to control the light when two specular units are used at different angles at the same time. This can be evaluated by examining the modeling on your subject.

When using a mono head, there are two methods you may use when adjusting the fill light to produce the desired ratio. First, there is the meter method. In this method, you meter the light and adjust the power output so that it reads 1½–2 f-stops less than the main light (depending on how long a ratio you want). The second is to set the modeling lamp on the fill light at the same level as the power level, then use your eye to adjust the fill light. Whichever method you use, it is important that detail can be seen in the shadow side. Otherwise, the result will be what is called split lighting.

Reflectors. Another very effective method for producing fill light is to use a white or silver

reflector panel at the shadow side of the subject. This panel is positioned to face the main light and, at the same time, redirect the light onto the shadow side of the subject. This usually means that you will place the reflector at an angle of 20 degrees from the camera, on the opposite side from the main light.

When using a reflector as a fill, you can see the effect of the fill without metering it. However, if you like, you can still meter this light source by measuring the reflected light. This is simply done by pointing the meter toward the reflector from the subject position. If there is a drawback to using reflector fill, it is that, if we have to place the reflector too far from the subject (such as in a full-length portrait) to avoid seeing it in our image, it may not produce a sufficient amount of light.

7. *The Gentle Look*

FOR A GENTLE LOOK, WE AIM TO PRODUCE A RATIO OF between 3:1 and 3.5:1. The lighting modifiers required to create this look will also be more diffused than those uscd to create the chiseled look. In this type of portrait, we want to have a lot more detail in the shadow side of the face, and the transition from highlight to shadow will be more gradual. This gentle style of portrait, nevertheless, still requires sparkling skin tones—especially on the highlight side of the portrait.

▶ SUBJECT-TO-LIGHT DISTANCE

The larger the light source (relative to the subject), the softer the light effect it creates. There is also, however, an optimum *quality* of light from all sources that you can use to obtain the best results. This can be clearly seen by a trained eye, but you can also roughly calculate the light-to-subject distance at which you will obtain optimum quality. To do this, measure the widest point at the front of the light modifier attached to the light head. Then, add this number to the distance from the front of the modifier to the flash tube. Divide this total by two.

For example, if the front of the attached unit (at its longest measurement) is 60", and the depth from the front to back of the unit is 12", we have a total of 72". When we divide this by two, we get 36". The distance range for optimum quality will be from 1–1.5 times this number (36" x 1 = 36", 36" x 1.5 = 54"). This means that the range of optimum quality of the light is from 36"

This gentle style of portrait still requires sparkling skin tones— especially on the highlight side of the portrait.

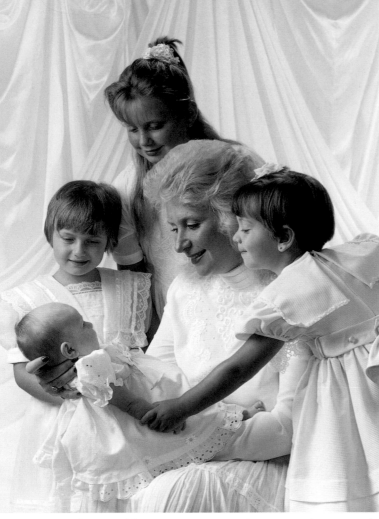

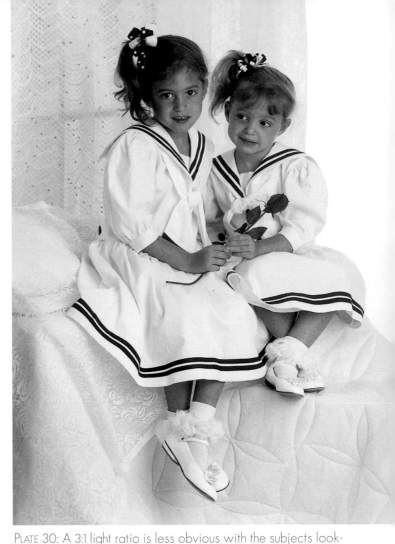

PLATE 29: There are many complementary elements within this portrait. There is a basic 3:1 light ratio, but because each head has a slightly different angle to the light and camera, there are varied lighting impressions of each subject. Note that the composition displays both diagonal and triangular lines, and that the modified background has been nicely handled. (Photograph: Kim and Peggy Warmolts)

PLATE 30: A 3:1 light ratio is less obvious with the subjects looking directly at the camera. Ratios are more identifiable when heads are slightly turned away from the camera.

(measured from the front of the light modifier) to 54". You now know that, to obtain vibrant skin tones, the front of your light will need to be 36"–54" from the subject (see DIAGRAM 11).

This calculation is an excellent starting point to use when determining the optimum quality of light. With careful observation, you will be able to see the effect of your lighting on the skin tones, and may find that you are even able to obtain satisfactory skin tone values with the light slightly further from the subject.

What this number also tells us about our lighting is that, the further away from our subject our light source will be, the larger it needs to be. It is important to remember that when we move a light further away from our subject it becomes smaller (in relation to the subject) and, therefore, less soft. It will also, at the same power output, become relatively flat. When the power is increased to compensate for the additional distance the light has to travel, the negative may be adequately exposed, but it may also render less vibrant skin tones.

▶ THE MAIN LIGHT
As you seek to produce what may be termed an average, middle-ratio portrait, you will normally choose between an umbrella and a soft box for your key light.

Umbrellas. If the modifier is an umbrella, there are four types

to choose from. One is an umbrella that has a silver/white surface. This type of umbrella comes in two distinctly different styles. The first has a silver base material covered by a white fabric. The light source travels through the white material and bounces off the silver back through the white fabric to produce a gentle light on the subject. The second option, producing a marginally harder light, is made of a combination of silver and white material. With this umbrella, the light does not have to return through a second fabric. It is therefore a little more specular and the power output is somewhat more efficient.

A third umbrella is that which is described as a "zebra." This umbrella is made of alternating panels of silver and white surfaces. This umbrella produces light similar to the silver-white combination material. It produces a little more "snap" than light from the umbrella made of two separate materials.

A fourth type of umbrella is one in which the light bounces off the silver surface and out through a reverse umbrella front. These are the Westcott Halo (an umbrella) and the Westcott Halo Mono (a soft box). With this umbrella, there is a slightly hot center with up to 15 percent light falloff at the outside edges of the umbrella. This is consistent with most umbrellas, as the light source is unable to cover a relatively shallow umbrella as efficiently as it can with a deeper-shaped one. (Light falloff also refers to how rapidly the light weakens between when it strikes the subject and when it hits the background.)

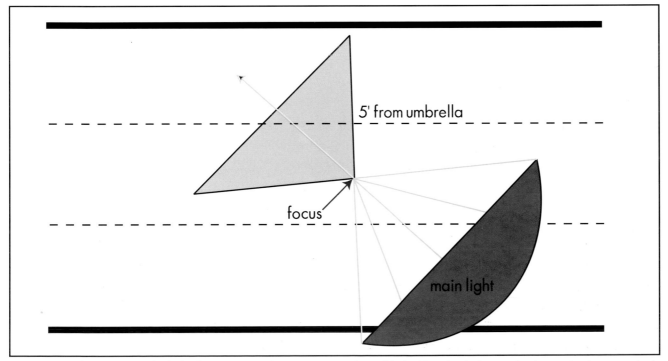

5' from umbrella

focus

main light

DIAGRAM 11: The point at which the lines meet is the optimum quality of light. The shaded triangle shows the limit at which the relative quality is comparable.

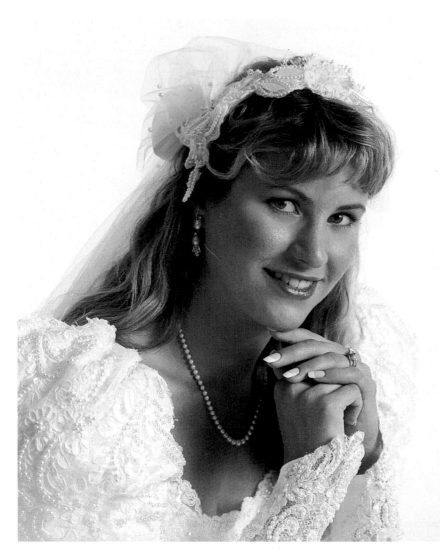

PLATE 31 (LEFT): A 3.5:1 ratio for this bride enhances the beauty of her gown—even in this close-up shot.

PLATE 32 (FACING PAGE): Although the background used here is in middle key, the portrait renders mostly whites and the overall tones are brighter than middle key. Hence it is high key. It emphasizes the point that a portrait can be defined as high key, even though the background is not white.

The size of umbrella you select is also important to producing a gentle lighting effect. For most portraits of individuals, and groups of up to six people, we should select an umbrella with a minimum 45" diameter. This minimum size is also recommended to ensure adequate coverage for ¾- and full-length portraits, as well as for groups—especially when there is to be a white floor area included in the composition.

When selecting an umbrella you need to be aware that many models are inefficient, either because light passes through the umbrella or a high degree of the light is absorbed by the base material. Check that any umbrella you purchase neither allows the light to pass through it nor absorbs useful light. There are also umbrellas that are constructed of a partially opaque material that allows up to 50 percent of the light from the tube to pass through it. This type of umbrella may be used as a shoot-through modifier, but is not suitable for our needs in creating the gentle look—especially in a small area, since it will scatter light all around the set. (A shoot-through modifier is one that is inefficient for bouncing light toward a subject, because too much light would be lost due to its transparent material. It is therefore used in front of the light source, as you would use a scrim.)

Soft Boxes. Many manufacturers offer what are commonly termed "soft boxes." They come in a multitude of sizes from 12" x 16" all the way up to 72" square. The options they offer in quality of light are almost as varied as their sizes. For most portraiture, boxes in the 20" x 30" to 30" x 50" range are adequate. Again, remember that the larger the

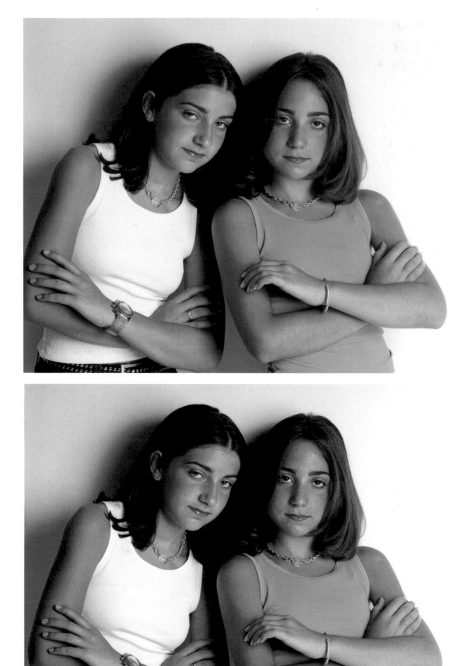

PLATE 33 (TOP): This portrait uses hard lighting to dramatize the pose and has a 4.5:1 ratio. You can see the effect of the hard light not only on the subjects but also on the background. .

PLATE 34 (BOTTOM): This image is of the same two young ladies, but modified in two ways. First, the hair has been pulled back behind the ear of the left figure, and the lighting has been softened to produce a truly soft impression (compared with the previous portrait). Changing the hairstyle is an option that the photographer may suggest.

source, the softer the light it produces. You will also want to use it at the distance from the subject where it provides optimum quality.

The choice among soft boxes is based on the same criteria used to select umbrellas: the materials and options. The interiors of most soft boxes are silver. They also have a white scrim that is placed at the front of the box. Just like umbrellas, many soft boxes also have a second scrim that can be placed between the front scrim and the flash tube. For the look we are seeking we will not use this second scrim. This is because the object is to take the edge off the specular effect of the silver interior by directing the light through the white front scrim.

When selecting a soft box for your more gentle-looking portraits, pay attention to the material that each soft box option offers. Some of the front scrim materials are extremely thin—almost transparent. These very thin fabric scrims will not adequately soften the light, and the effect you'll achieve with them is likely to be similar to the chiseled look described in chapter 6. You can determine whether the scrim is adequate by examining the modeling lamp through the front scrim. If the lamp can clearly be seen through the scrim, it is too thin. To create a gentle effect, the material must completely obscure the modeling lamp (though you may see a slightly hot spot).

▶ THE FILL LIGHT

The choice of a fill light should match the key light in quality. It should never be harder or more specular. If you use a more specular fill light, you will create an image that has opposing light patterns that are likely to be distracting and unflattering. However, the fill light may be *softer* than the key light. For example, the fill light may be an umbrella that has a totally white surface. This will produce a softer light than the main and still allow you to control the light ratio.

Umbrellas. An umbrella fill light should be placed as close to the camera as possible. Umbrella lights are a less controlled light source than soft boxes, so it is also recommended that the fill light umbrella be a slightly smaller diameter. This will better enable you to control its spread. For single subjects and groups of up to six, an umbrella with a 36" diameter should be adequate when used with a main light of a 45" diameter.

Soft Boxes. Similar principles apply to the selection of a soft box fill light. You can use a soft box that offers two scrims and use them both, or use the box with just the front scrim. Either option will work very well. As with the white umbrella, the difference is that two scrims will produce a softer light than the key light

(which uses only the front scrim). As with umbrella fill, you can also use a smaller soft box for fill light. It should be placed as close to the camera as is practical.

Reflectors. An alternative fill light source can be created by combining a mono head with a reflector. The mono head is directed away from the subject toward the reflector panel (or a rear wall), which bounces fill light back onto the subject.

Reflectors produce very effective fill lighting. Reflectors are available in rectangular, circular and elliptical shapes and in numerous sizes. These reflectors come in white, or white on one side and silver on the reverse side. Your choice will depend on the subjects you are photographing. You should have several reflectors available so that you can select the most appropriate one for your portrait. For the gentle look, it is recommended that the white side be used. Stands are also available for reflectors, and some reflectors even come equipped with a stand.

The reflector method is very effective, and is employed by many photographers because it can be left as a constant for all types of portraiture. It is not specifically recommended here, because we are discussing methods that require accurate control of the lighting. Bouncing light off the rear wall or a reflector panel is

much more subjective than using a softbox or umbrella. It must be personalized to meet the needs of the individual photographer as he experiments and develops successful methods.

▶ ADDITIONAL FILL LIGHT

With any of the above lighting setups, you may want to use an additional fill light that is placed in front of and below the subject. This will lighten the shadows that fall under the subject's chin. The best choice for this additional fill light source is a silver or silver-white reflector. This reflector should be placed so that it is slightly angled toward the subject and care should be taken to ensure that it does not interfere with the overall lighting pattern.

8. The Soft Look

T HE TWO PREVIOUS CHAPTERS REFERRED TO LIGHTING USED for a chiseled look and a gentle look—portraits that have what may be described as average contrast. Some portraits, however, will be much more effective and appealing if they are shown with below average contrast, and can be described as genuinely soft.

Before we begin, there are two things to note. First, it is important to point out that there is a distinct difference between *soft* and *flat* lighting. Both styles of lighting can be used to produce

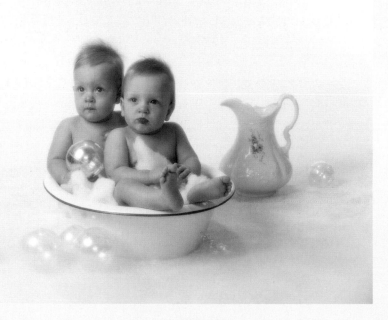

PLATE 35: Many of the elements discussed in this book are shown in this portrait of two babies in a bowl, taken with a controlled 3:1 light ratio on a high key set. The jug is perfectly placed and the bubbles have catch-light-like reflections, while the babies display beautiful skin tones. The jug and the ground to the left are a little grayed to help draw the eye to the babies. (Photograph: Kim and Peggy Warmolts)

beautiful portraits, if the right techniques are used. In this chapter, we are discussing soft lighting techniques. We will deal with flat lighting techniques in chapter 10. Second, it should be noted that, when using soft lighting, the choice of background is important. Unless it is very carefully handled, a softly lit portrait needs a matching background. We will deal with backgrounds in greater detail in chapter 11.

► THE SOFT UMBRELLA
MAIN LIGHT

The main light for this style of portrait must be modified to reduce its specularity. Therefore, the umbrella you use should be made of a white fabric (or other material).

As in all other light modifier choices, there are numerous differences in what manufacturers refer to as "soft lighting" options. For example, there are umbrellas that are made of bright white plastic materials that are a little less soft than those made of white fabric. Because umbrellas are made of materials that vary in reflectance or absorption, they also vary in the amount of light they put onto the subject. In addition to being a little less soft, the plastic surface may produce as much as half an f-stop more light.

Placement. As previously noted, the larger the light source (relative to the subject), the softer the light it emits. That said, you will want to use an umbrella that is between 45" and 60" in diame-

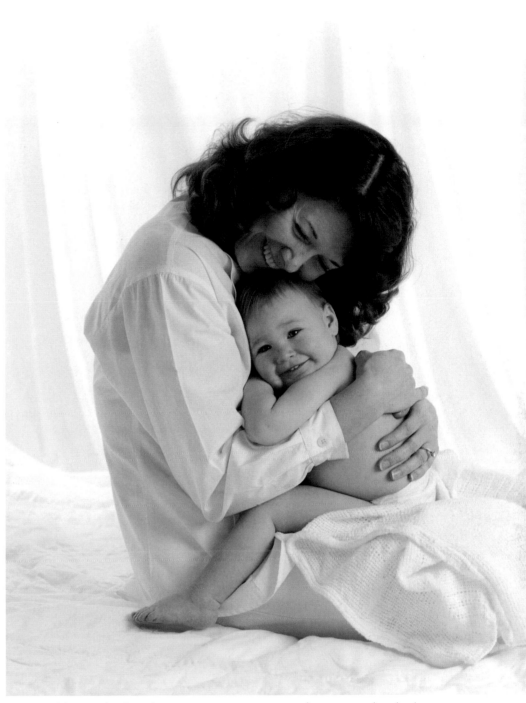

PLATE 36: Here in this love hug portrait, a 3:1 ratio can be seen in the shadow side. Because this light is relatively gentle on skin tones, the mother's head is nicely rendered, even though it is tipped away from the angle of the light.

PLATE 37 (ABOVE): This portrait, titled "Earth Angel," is beautifully vignetted and perfectly exposed. The overall intensity of the white helps to slightly diffuse the image and create a little magic. Note, too, that the child's nose is slightly washed out. Because the lighting has been so well done, however, it has not merged with the background. (Photograph: Kim and Peggy Warmolts)

PLATE 38 (FACING PAGE): This is a simple high key portrait, photographed using the basic high key set. Note the reflections of the child's feet on the floor and the gentle shadowing below the seat. This provides a base for the portrait, preventing the child from looking as though she is suspended in a white field.

ter. We have also established that we can place the light in such a way as to use the optimum quality of the light produced by our modifier. For this soft effect, you should place your umbrella closer to your subject than you might have in the sets previously discussed—right up to the ultimate point of the quality of light. With the soft lighting in this type of portrait—especially with either a very white or relatively bright background—ensuring the optimum quality of the light is essential. If you do not do so, it is likely that the desired softness may instead seem somewhat flat and lacking in cleanly rendered skin tones.

► FILL LIGHT FOR THE SOFT UMBRELLA MAIN LIGHT

A soft main light offers a delightful option: you may not need (or desire) to use a separate light source as a fill. Instead, you can use a reflector that matches the softness of the main light. This may be either white card, a white reflector disc (such as the Lite Disc, a Monte Illuminator or similar type). The reflector panel or disc should be placed close enough to the subject to produce the amount of reflected light needed to illuminate the shadow side of the subject, and maintain the ratio you desire. In this type of portrait, a 3:1 ratio is a good starting point.

If a separate light source is considered necessary, it should also be as soft as the main light.

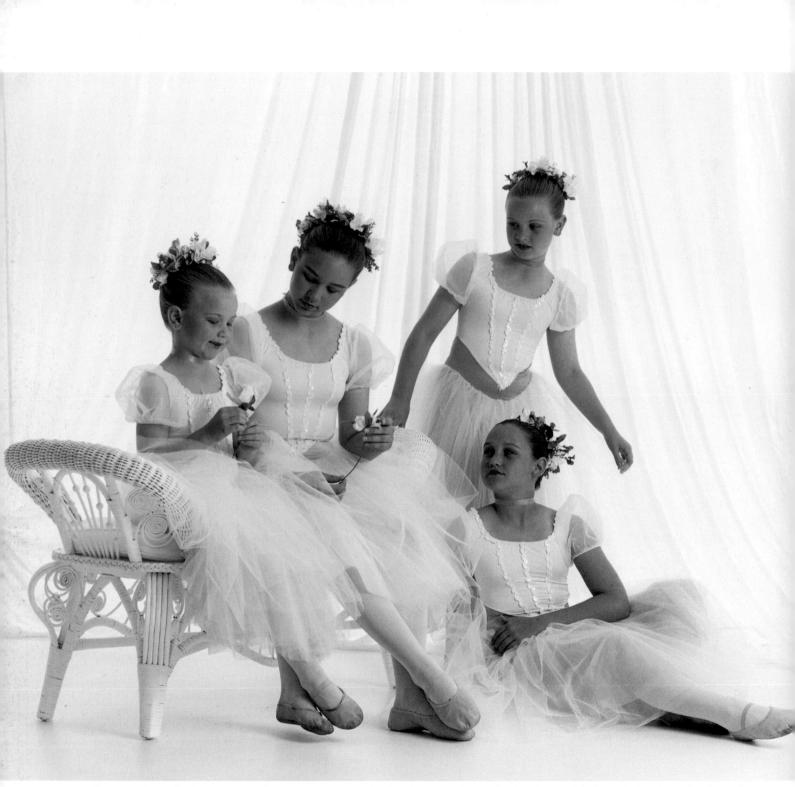

PLATE 39 (ABOVE): This portrait of a group of young ballet dancers shows the background lighting behind gently draped satin fabric. Satin or satin-like material is only slightly opaque. It is also an excellent transmitter of light, and helps to retain the clean whites. This creates a very gentle hint of the draping, which does not detract from the portrait.

PLATE 40 (FACING PAGE): The white dress and the light areas of the pillar and seat cause the average tonal range of the portrait to be just at the edge between high and middle key. Only a master of portrait lighting can pull off this type of portrait without mixing keys. Note the beautiful luminance of the skin tones and the sparkling eyes. (Photograph: Jeff Lubin)

The primary difference is that it does not need to be as large as the main light. It may also be an umbrella, and can be as small as 36" in diameter. The most important thing is that the fill light should not be at all obvious in the image. It should be very subtle. If the main light is set at f-8, then the fill light should meter at f-4. This may appear to contradict what we discussed earlier. However, the situation is somewhat different here because the main light, being large and soft, already creates a degree of wraparound light that provides partial fill on its own. Therefore, we need less than the usual amount of fill light to achieve the desired 3:1 light ratio.

▶ SOFT BOX MAIN LIGHT

If you decide to use a soft box as your main light, you should use a box that (as was previously discussed) offers two diffusing scrims. The second scrim reduces the specularity that is present when only one scrim is used. When the specularity is reduced, the light will wrap around to a greater degree. When positioned close to the subject, this light may be used without a separate fill light source.

Bearing in mind the principle that the larger the light source relative to the subject, the softer the light, you should use a box that is 40"–60" tall and at least 20" wide. Positioned at the correct distance to provide optimum quality, this width will be sufficient to wrap the light around the subject. A narrower source may prevent you from producing a wraparound effect and will, therefore, require a separate fill light source. The width may be up to 40" (or more), if the box is equipped with the option to place black blocking panels on it to control the source of illumination.

9. High Key Backlighting

BACKLIGHTING IS A TECHNIQUE FOR PRODUCING IMAGES that are primarily lit from behind and delicately lit from the front. In high key, this style can be delightfully effective. For the technique to be successful, the distance between the subject and the background must be determined by the amount of light that is reflected from the white background.

► THE BASICS

To begin, use the basic high key set discussed for the gentle and soft-look lighting setup. Then, either eliminate the main light, or reduce its intensity. (Eliminating the main light and using only the fill light used in the gentler look portrait style will attain the best results.) Using the sets we have described so far, a reflector is not likely to produce adequate front illumination to define the subject. The resulting portrait may even seem to have gone wrong! For this type of image to be attractive, the balance between the light from the rear of the subject and that from the front must be accurately determined.

► LIGHT RATIOS FOR BACKLIGHTING

Assuming that we are using a ratio of between 3.5:1 and 4:1 on our basic high key set, we can successfully eliminate the key light and produce an attractive image. If our ratio were at 3:1 and the subject was in light clothing, the result would not be quite so effective. This is because the overall light on the set could render the

For the technique to be successful, the distance between the subject and the background must be determined by the amount of light that is reflected from the white background.

front as flat. For backlighting to work well, it is necessary to partially silhouette the subject, yet show enough detail on the front to define the person. When eliminating the key light that is normally used in the sets previously described, the fill light from that set is all that is left to illuminate the subject from the front. It should be just adequate to show detail in the shadows within the ratio of 3.5:1. Therefore, if the original key light was set at f-8,

then the fill light should be set to produce f-4.5.

▶ SUBJECT PLACEMENT

The position of the subject in the high key set is also important. For this special effect, sufficient light from the background must create a highlight around the edges of the subject—without causing the edges of the subject to disappear into the background. The subject should be placed in the set so as to produce a 2:1 ratio between the

subject and the background. This position is in the center of the shooting zone (as described in chapter 2). If the subject is any closer to the background, there will be a burned-out effect around the subject and the person's shape and form will be lost. Alternately, if the subject is placed too far from the background—say at the front edge of the shooting zone— there will be a more solid silhouette that will not have the same delicate subtleties.

PLATE 41 (FACING PAGE): Backlighting can be a versatile method for creating different impressions from a single negative. In this example the black & white image has been printed very delicately, to produce an almost ghostlike image. This same negative could be printed with an additional stop of density so that the blacks would be blacker and the skirts would be more defined, making the images more like a silhouette. The main light was not used for this portrait.

PLATE 42 (BELOW): The same group of girls is shown here on the same set—this time in color. If you compare it to the black & white portrait, you'll see it has been printed down to bring in the skin tones. At the same time, the main lighting from behind produces beautiful modeling and rim lighting while still highlighting the dresses in a delicate manner. Again, the main light was not used in this portrait.

10. Flat Lighting

THE SUCCESSFUL USE OF FLAT LIGHTING AGAINST A BRIGHT background with the high key lighting requires thoughtful application of the techniques we will discuss, or the images will appear somewhat drab. We will discuss four techniques that will produce beautiful flat-lit portraits.

▶ FLAT LIGHTING: TECHNIQUE 1

Subject Placement. The first method for producing flat lighting (and still retaining high key) is to place your subject near or at the background. With the subject in that position, the person will cast a shadow that creates separation between himself and the background. The subject will be very evenly lit and the hardest shadows will be those on the background. These shadows will not extend much beyond the subject, but will primarily fall immediately behind him.

Light Ratio. With the subject in this position, you will need to make sure that your lighting is very even—with little or no identifiable light pattern. You will be virtually eliminating any light ratio—so that it is between 1:1 and 1.5:1.

Light Positions. In this mode, your main light will be more frontal, and much closer to the camera than in previous setups. The fill light will be placed over the camera position, creating what can be described as a "form" light. Your two light sources will now virtually be one. Ideally, the modifiers used on these lights should be a minimum of 45" (if an umbrella) and 40" x 24" (if a soft box). Smaller sources may produce a less flat light—especially

The successful use of flat lighting against a bright background with the high key lighting requires thoughtful application of the techniques we will discuss, or the images will appear somewhat drab.

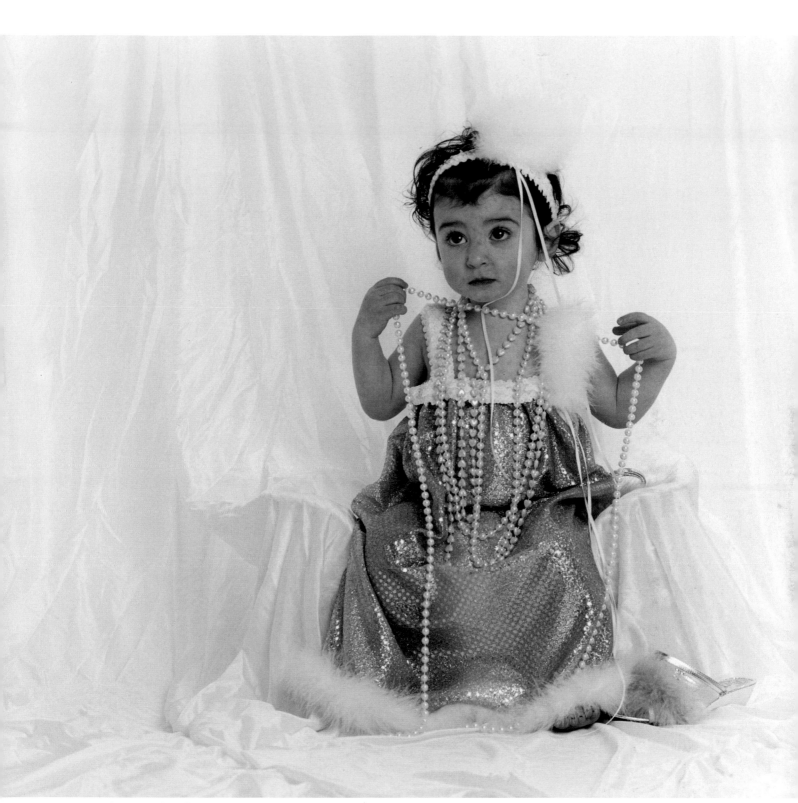

PLATE 43: White pearls, white satin drapes, delicate pastels and baby skin tones are all rendered delicately by the use of flat lighting. The drapes are deliberately wrinkled to enhance the feeling of texture. Note that the baby is not planted in the center of the composition but in the right-hand third.

placed more than 6' from the subject. In close-up or torso portraits, you may also want to use a silver reflector placed in front of and below the subject to reduce the intensity of the shadow that the high position of the main light will create under the chin.

Light Modifiers. All of the previously described light modifiers will be effective in creating flat lighting. The chiseled-type lighting modifiers will produce very clean and bright skin tones. The modifiers noted for the gentle look, however, will produce more skin-tone fidelity. This effect will be even more pronounced when using the modifiers chosen for the soft look.

Another modifier that produces a flat light is a pan reflector. This is normally at least 16" in diameter with a silver or aluminum surface, and has a small disc that is placed in front of the flash tube to reflect the light back into the total area of the reflector. The light from this modifier tends to be a little harder than the other modifiers we have discussed but, when used close to the camera, it produces a very bright, flat light.

Exposure. The effect of this style of lighting may be enhanced by overexposing the negative and printing the image with less density. This technique is often used in photographs advertising hairstyles and eye makeup, and can be very attractive. Overexposing also helps to eliminate skin blemishes and laugh lines. However, underexposure will produce an image that has a muddy appearance, or one that shows unflattering skin tones.

▶ FLAT LIGHTING: TECHNIQUE 2
A second method of creating a flat light effect is to place the subject against a white or light background and use a modifier that softens the light to a point that it appears flat.

Light Modifiers. There are two units in particular that produce this type of light. One is a soft box that has an 18 percent gray interior and two diffusing scrims. With this unit, light is directed through the scrims (just as with those with silver or white interiors), but it does not benefit from the more specular interiors and is therefore ultrasoft. The reason for this is that, with a silver or white interior, the light emitted from the flash tube falls off much more slowly than it does with a significantly less reflective surface. Therefore, this is essentially a form of subtractive lighting—when we use this method we are essentially reducing the specular reflectance value of the original light source.

The second modifier for this type of lighting is an umbrella that has a soft white fabric over a black base. The black base absorbs much of the power produced by the light source and eliminates the specularity, so that the light reflected off the white cover will be ultrasoft.

Light Placement. Either of these light sources may be placed

PLATE 44 (FACING PAGE): This is a great example of how one can create a little bit of magic with subjects on the floor with overhead flat lighting. (Photograph: Dennis Craft)

PLATE 45: This popular image, entitled "Backs to the Future," uses flat, soft lighting to cover a wide spread across the shooting zone of the basic high key set. The babies are positioned as close to the backdrop as possible without washing out their skin tones.

anywhere between the camera axis and 45 degrees off-camera. However, the light is flatter when the light source is placed close to the camera position. When the light is placed further off-camera, while still a flat light source, it may create a longer ratio—especially if the source used has a relatively small diameter. In either case, the main light will illuminate the subject and also fall onto the background at both sides, retaining the high key effect.

Exposure. It is recommended that, after taking an exposure reading, the image should be overexposed by half a stop. If the meter reading produces f-8, you should expose the image at f-6.3. This will assist in rendering clean, more luminous skin tones. With this type of lighting, there is a much greater tolerance for overexposure than for underexposure.

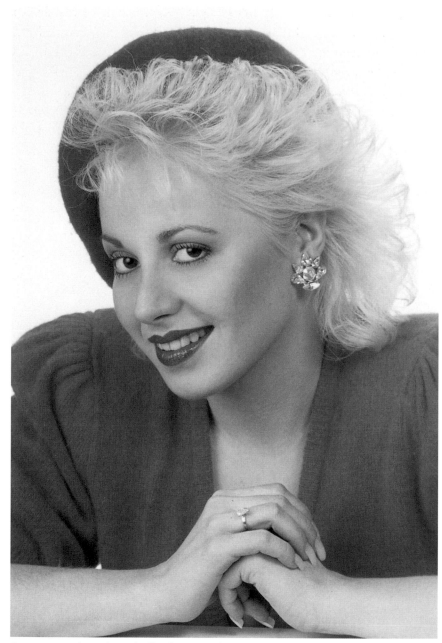

PLATE 46: In this relatively flat-lit pose, the subject is blond and her rose-colored cheeks appear to create a longer ratio because of the contrast between the cheek color and the blond hair.

▶ FLAT LIGHTING: TECHNIQUE 3

A third technique used to produce flat lighting is to position the subject as discussed in previous chapters (i.e., in the shooting zone).

Light Source. The preferred light source for this set is a pan reflector, which has always been a favorite with glamour and model photographers. The light it produces is comparatively hard and should be placed immediately over or to the side of the camera. This position virtually eliminates any shadows and renders an image with wide-open, bright skin tones that can be very flattering. Additionally, this type of lighting will reduce the need to retouch lines and blemishes, since the angle of incidence is so narrow that it is virtually shadowless. (If you like, you can also use any of the other modifiers previously described.)

▶ FLAT LIGHTING: TECHNIQUE 4

For this technique, the subject needs to be placed at the background so that an almost equal amount of light falls on both.

Light Position. Place a very large light source behind the camera. In the camera room, this source will need to extend across most of the width behind the camera. The light from this source may be diffused or direct from the flash tube. With an undiffused source, you will need to use reflectors to ensure an even lighting pattern. With a diffused source, the light will more naturally produce an even pattern.

Light Source. There are several ways to create this lighting. The first is, obviously, to use a very large soft box—a luxury for most camera rooms. Such a light source would be similar to having a room-width window with north light behind the camera. A second option, and one that is less expensive, is to direct one or more bare flash tubes toward a white wall or toward an expansive white reflective panel (bouncing the light back onto the subject). This will produce an even light source that will render the subject virtually shadowless and without a definable light ratio. This light may be of varying intensity, and could require exposure anywhere from f-2.8 through f-8—or even smaller apertures.

Observing the effect of flat lighting tells us that this form of light has a much greater wraparound effect than soft light, which in turn has a significantly greater wraparound effect than more specular light. In the camera room, we select our lighting methods to produce specific results. Therefore, the decision to use flat lighting has to be based on its power to flatter our subjects.

11. Modifying the Background

I N THE LIGHTING SETS WE HAVE DISCUSSED SO FAR, WE HAVE used a plain white or light-colored (pastel) background. While a plain background is often desirable, there are many occasions when you will want to produce a background with more texture—or one that has a closer relationship with

what the sitter is wearing. You also may wish to create a background that is based on a stylized room set. In each of these cases, the way you light the background will have a significant impact on the end result.

In the first two suggested techniques for lighting modified backgrounds, the basic high key set already discussed will not have to be modified.

► TECHNIQUE 1
The background in images created with the first technique will have a soft look that is ideal for infant or mother and baby portraits, as well as for portraits of families

and children dressed in light (especially white) clothing.

Background Material. To begin, position a translucent or partially opaque material between the sitter and the background zone (as described in chapter 2). This material is best positioned at the dividing line between the background zone and the shooting zone (this means it is in front of the background lights). If the material is plain, such as a satin or similarly textured material, it will need to be draped in such a way as to create a pattern of delicate shadows in the finished image.

You can choose from a variety of materials, so long as they are

While a plain background is often desirable, there are many occasions when you will want to produce a background with more texture—or one that has a closer relationship with what the sitter is wearing.

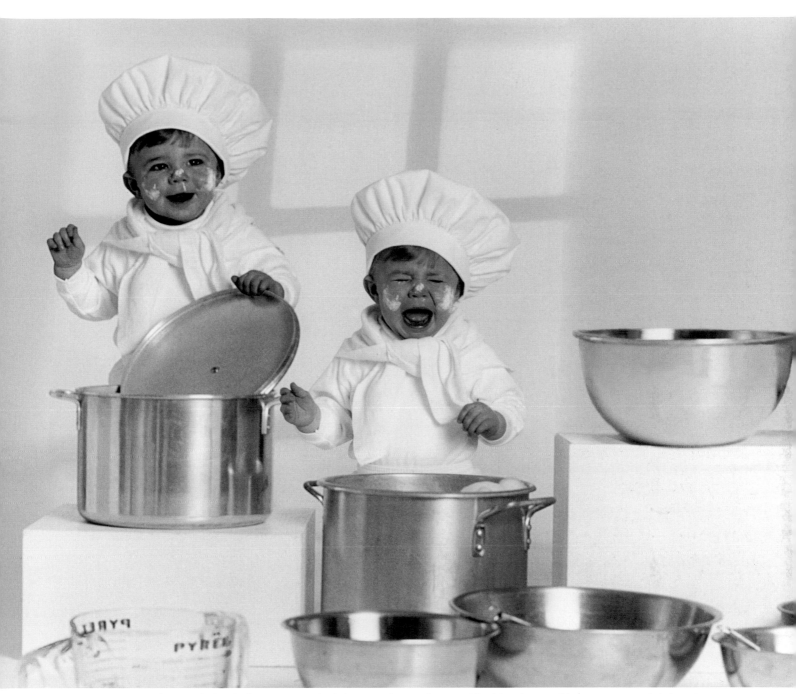

PLATE 47: "Sweet and Sour" little chefs maintain a high key tonality with a modified background by using a cookie (used like a filter in front of a lens but placed in front of a focusing spotlight instead). The pattern cut on the cookie directs a pattern of light onto the background, in this case the shape of a window, so long as background lighting is not used. Note the diagonal line from the chef at the left to the white box at bottom right that creates a pleasing compositional line. In order for this to render as high key, the subject must be close enough to the background to permit adequate light to fall on it.

sufficiently translucent to allow at least 40 percent of the lighting on the background to pass through the fabric toward the camera. Normally, a light or white fabric such as satin, lace or gauze will allow adequate light transmission. If in doubt, you can meter the light through the fabric.

Metering the Background Light. There are two ways to meter this light. One is to use the spot-metering mode and aim it at the background from the camera position. If the exposure of the subject is f-8 then, from the camera position, the spot meter should read not less than f-4.5 on the background (or not more than 1½ stops less than the main light). A reading of less than f-4.5 indicates that the background will render in the middle key zone.

The second method of metering the light coming through the background material is to use the incident-metering mode. Position yourself at the rear edge of the background zone (as described in chapter 2), and aim the meter at the background. Again, if your subject is at f-8, look for a reading of not less than f-4.5.

White Materials. When using white material on the background, you need to take extra

PLATE 48: This portrait, entitled "The Hackers," employs the same technique used in "Sweet and Sour." Here, a host of props were used to create a fantasy image. The high key effect is retained by the overall brightness across the total image. The key to this is accurate exposure that captures all the elements and allows them to separate.

care. Based on an exposure of the subject at f-8, a reading of less than f-5.6 may cause the background to appear gray and produce ugly shadows on the draping. (Of course, if the subject is appropriately dressed and you wish to produce an unusual effect, this may not be undesirable.)

► TECHNIQUE 2

The second suggested technique for changing the texture of the background requires the same material used in the first method, but positions it at the back of the background zone. This allows the background lighting to be directed at the material (rather than *through* it).

Suspending the material flush to the background will create a slightly different effect than suspending it in front of the wall. The final look you achieve will also depend on the method used to hang the material, as well as the position of the background lighting units. The following are a few guidelines for what to expect with the background material flush to the wall:

PLATE 49: In this portrait, the background is modified by the drapery, softening it so that it does not clash with the subjects. You will also note that the girl on the left has a loop lighting pattern below her nose. Because the girl on the right is slightly turned, she has more of a butterfly shadow below hers.

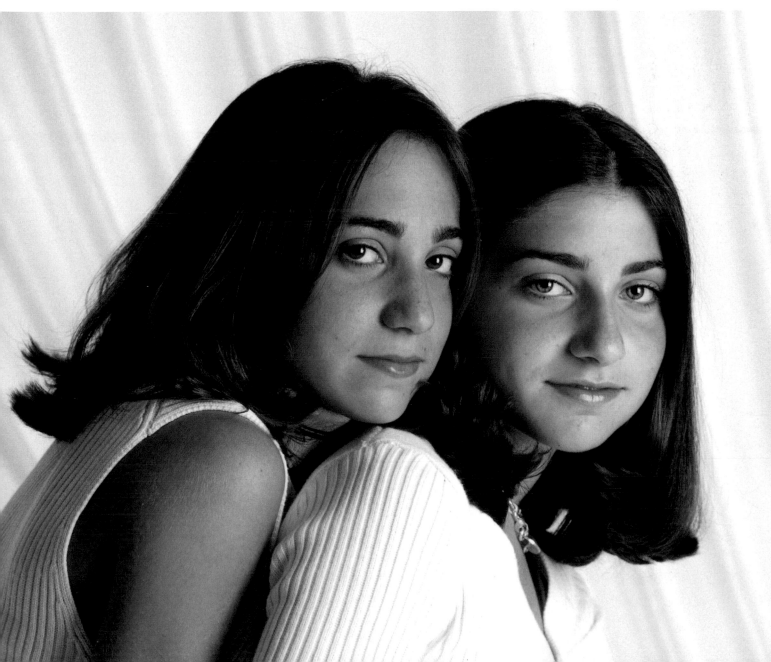

• With the lighting units set above it (as with a ceiling-mounted system or using booms), the background texture will appear more delicate, with subtle shading where the folds in the drapes are nearest to the camera.

• With the lighting units placed to the sides of the background, the drapes will display much stronger shadowing. This is because the angle of the light is more oblique and creates harder shadows. In this case, it is recommended that fabric be draped in more shallow folds (in effect, the fabric will be stretched a little wider). Otherwise, the contrast between the shadowed folds and the bright white of the fabric will be too high for most high key subjects. Such an effect is best used when strong contrast is specifically desired in the background.

• With the lighting units directed from either the side or above, light will travel through and bounce back off the wall, passing through the material and creating a much

PLATE 50: Here is an example of modifying the background by shading in the top left-hand corner. This helps to lead you to the subject. The dark clothing and the 4:1 ratio almost disqualifies it as high key, but because the background is white, it is still considered high key.

HINTS AND TIPS

It is important to remember that to be high key, a tone must be two f-stops brighter than 18 percent gray. If the subject is not more than 24" from the background material, and the meter reading is less than f-4.5, then the combination of light from the background lighting, the main light and the fill lights will ensure a high key image. When the subject is placed at the front edge of the shooting zone (36" from the background material), then the background may be marginally high key or fall into middle key. It is important to retain a ratio of not more than 3:1 between the light on the subject and that on the background as it appears from the camera position.

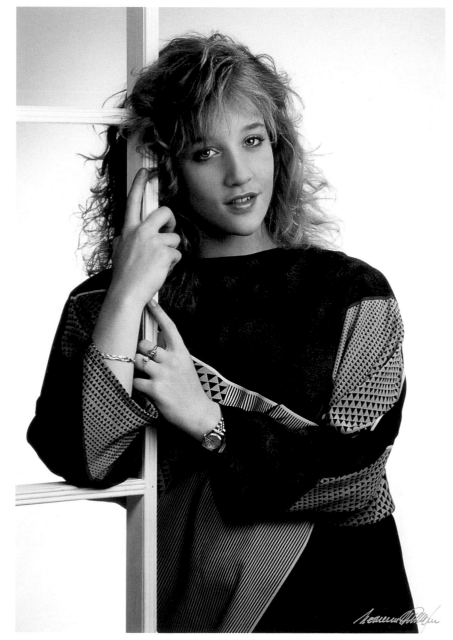

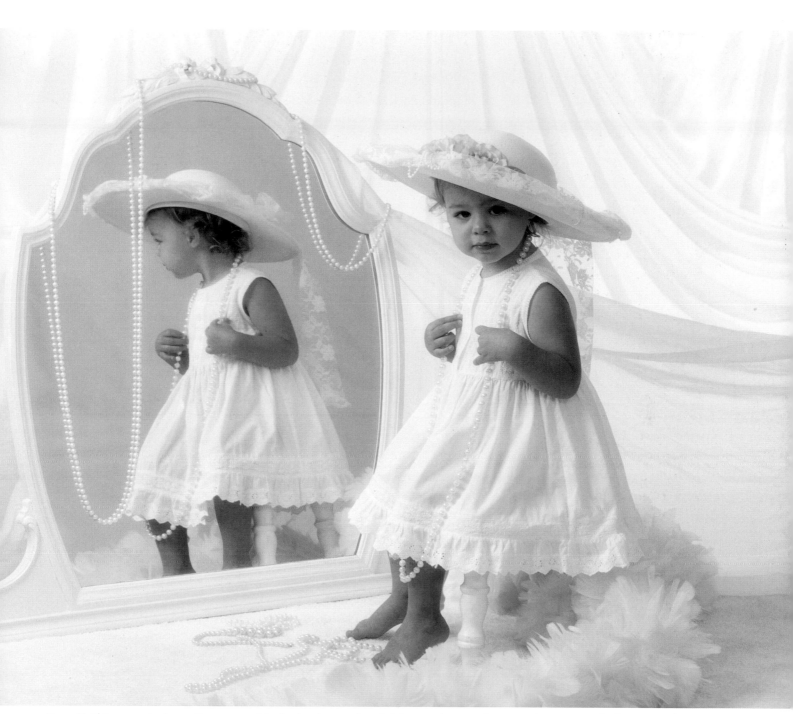

PLATE 51: This portrait shows how to modify the background with fabric and props. Because the mirror is further away from the camera than the subject, it becomes more than a prop. It is important that what is shown in the mirror is close to high key, or it will become a distraction and also break down the composition. (Photograph: Kim and Peggy Warmolts)

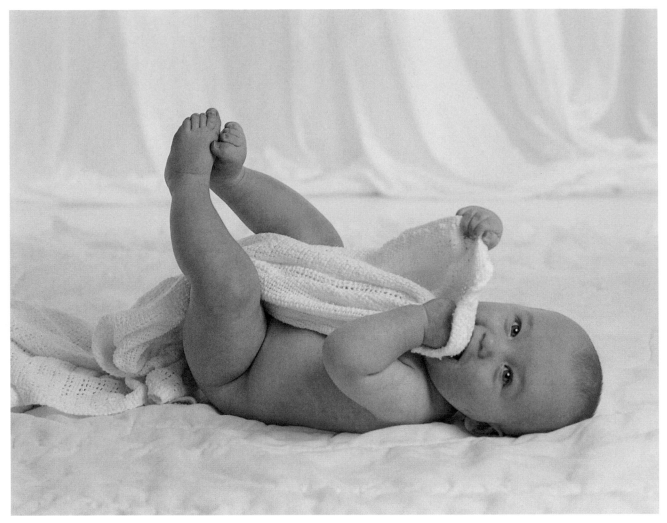

brighter background in the portrait. The effect of the draping will be less pronounced, and the contrast values will be much more delicate.

You can also split the background lighting by placing the material so as to allow the light to strike both the background and the fabric at the same time. This will result in an appearance that will fall midway between that achieved when the fabric is at the background and that achieved when it is placed at the front edge of the background zone.

► TECHNIQUE 3

This technique is relatively simple to achieve. It requires a spotlight or an attachment for a standard mono head that enables you to use what are referred to as cookies. These cookies are lighting accessories, mostly made of aluminum, which have patterns cut in them. They are available in numerous designs—some of which are a little bizarre. These cookies are placed in front of the light source and focused onto the background (with the background lighting turned off). The spotlight should be zoomed in and out until an appealing, appropriate pattern is

PLATE 52 (ABOVE): This naked bundle of joy is on a set totally modified by fabrics—both on the floor and the background. You can see how clean the whites are, yet they have lots of texture.

PLATE 53 (FACING PAGE): In this portrait, reducing the intensity of the light until it is almost middle key modifies the background. The average brightness of the total image keeps it in high key.

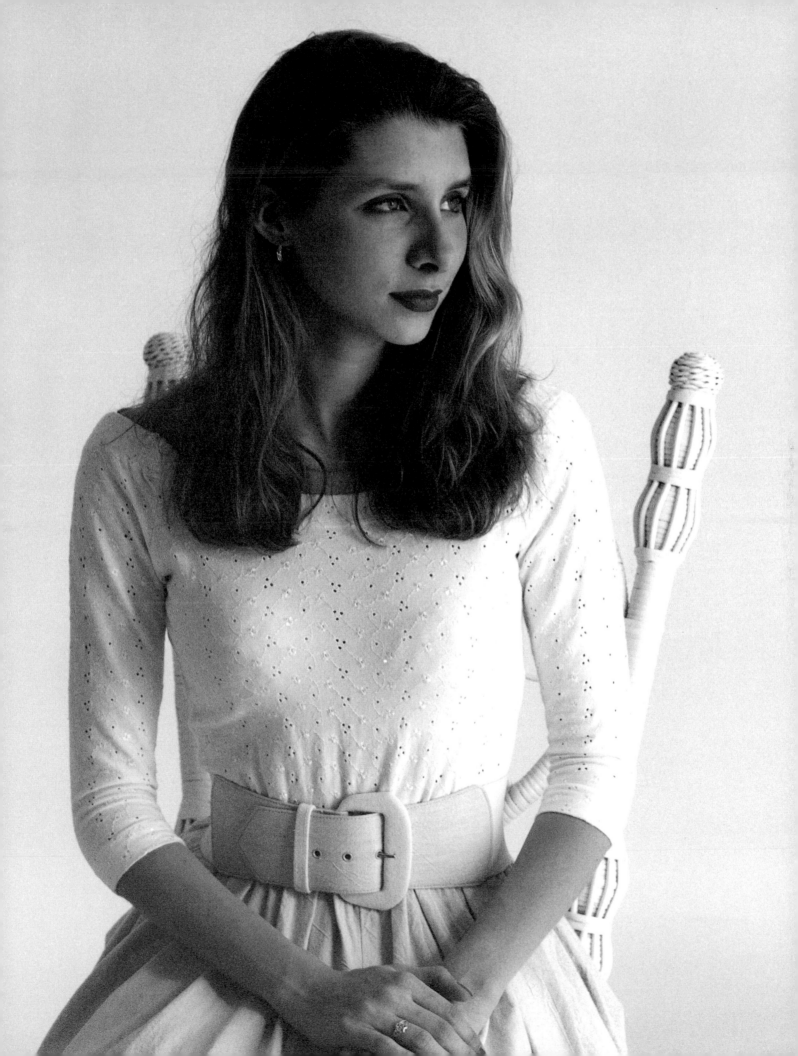

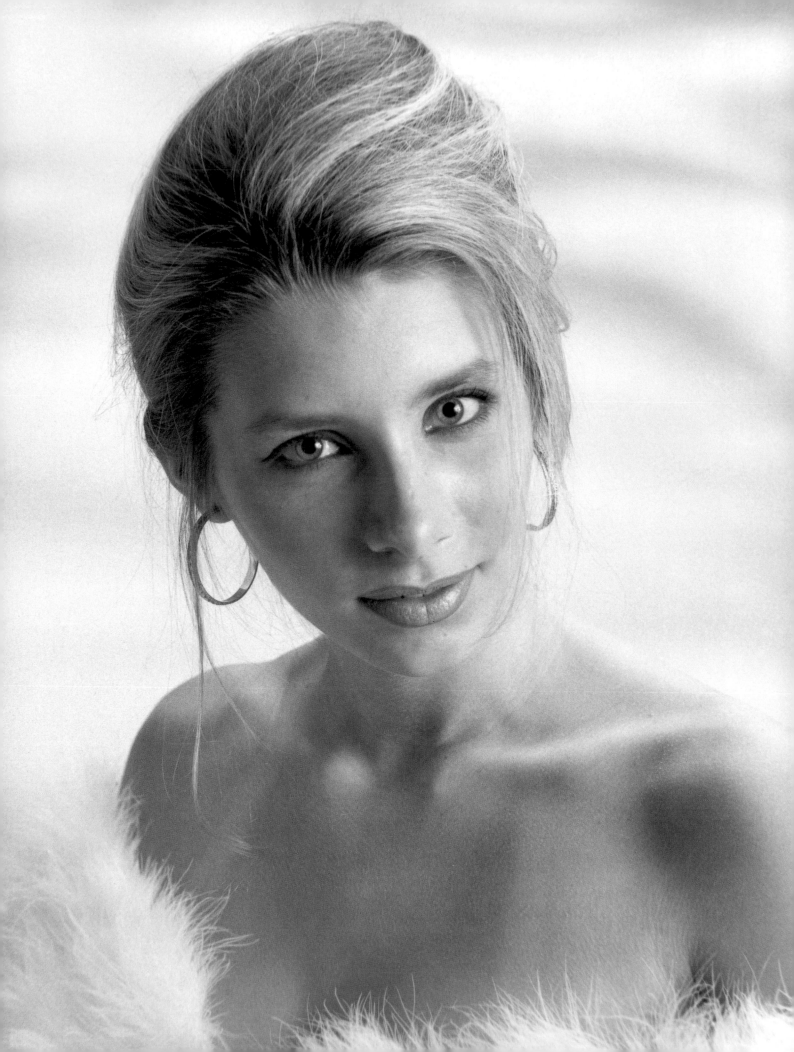

PLATE 54: Rendering skin tones in high key black & white requires accurate exposure. In this portrait with a 3.5:1 ratio and the background light modified by a cookie, the exposure had to be right or the delicate feminine shoulder lines would be lost.

created on the background. Keep in mind, at the same time, that you must create a sufficient amount of light to retain the high key tonality.

► TECHNIQUE 4

This technique simply requires placing tinted background fabrics, such as muslin or canvas, behind the subject, as shown in Plate 5 (page 17). There are many to choose from, but those most appropriate for high key portraiture are those in light or pastel colors. Some photographers use backgrounds that have delicate impressions of scenes or foliage. If you select such a background, you will have to decide whether you want any of the detail to be clearly identified in the portrait. The most effective backgrounds of this type have nondescript details that

can easily be made to blend together. With these details out of focus, you can achieve a delicate, cloudy effect. Generally, it is best to use warmer colors with a slight hint of gray or blue. These, when pushed out of focus, produce a background that is complementary to your subjects.

The options discussed in this chapter have demonstrated that there are numerous techniques that you can use to modify your backgrounds to complement your subject and create sets that are attractive and artistic. The most important thing to remember is that, to retain a high key set when using fabrics or any other material, your meter reading must be at least two f-stops lighter than 18 percent gray. Anything less will cause the background to fall into middle or low key.

12. Outline Technique

AN INTERESTING AND EFFECTIVE LIGHTING EFFECT FOR high key involves creating an image with black edging. This is similar to etching, but is achieved by using black panels at the sides of a subject who is wearing white or light-colored attire. The technique is most effective when the subject is fair-skinned and blond, and may be described as "black lighting" or subtractive lighting. Normally we refer to subtractive lighting as a means to reduce the intensity of the light falling onto the subject (in any of the three keys). Black lighting is almost a misnomer, because the simple terminology of light suggests something totally contrary to black. But, for our purpose it is a fair description of what we are actually doing.

▶ STUDIO TECHNIQUE

Subject Placement. Using the basic high key set, as described in chapter 2, the subject is placed at the front edge of the shooting zone. This placement of the subject is important; positioning the subject any closer to the background zone would cause light reflected off the background to interfere with the optimal performance of the black panels.

Black Panels. Next, place a black panel at each side of the subject. The panels should be moved in as close as possible to the subject (or as close as is needed so that you are able to see a black edge all around), but should not interfere with the desired lighting pattern or intrude into the composition. Ideally the panels should be no less than 18" wide and at

This is similar to etching, but is achieved by using black panels at the sides of a subject who is wearing white or light-colored attire.

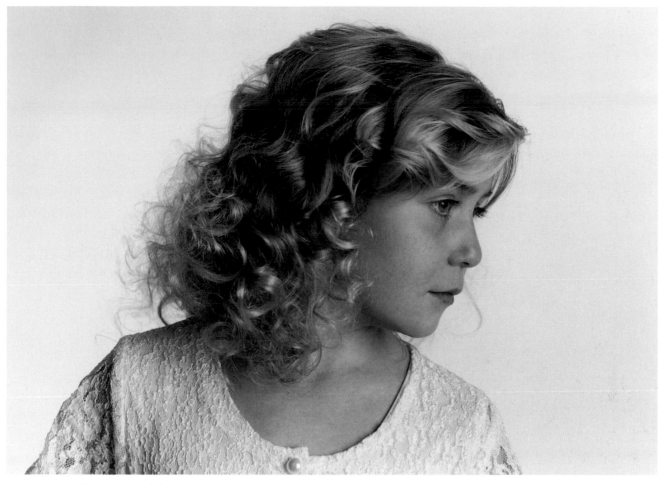

PLATE 55: With traditional lighting in this pose, the contour of the profile would display the same skin tone as the rest of the face. With the outlining technique, there is a perceptible darker outline that changes the visual effect. There is also a slightly darker outline on the girl's dress at the right. Additionally, the black panel has created much more definition on the shoulder on the left, helping to separate it from the background. With traditional lighting, this edge would have been softer and less well defined.

least 12" taller than the subject. The height of the panels is important, since there is area of reflectance factor. (The reflectance factor is the ability of the reflector to cover the area it is required to effect. When a reflector is not placed correctly or is not large enough to achieve its objective, its reflectance factor is too low. By the same token, when a reflector is too large, too specular, or too flat it may negatively affect the lighting pattern.) The panels must be tall enough to ensure that light does not intrude into the path of the shadow on the light colors and skin tones of the subject. You can construct these panels using two 4' x 8' sheets of ⅝"

thick Gatorfoam. Cut each sheet into three 16" wide sections, paint them black and hinge them concertina style. These panels can also double as subtractive lighting panels, or as blockers for other lighting styles—making them a very useful investment.

▶ APPLICATIONS

Outlining can be used for head and shoulder, ¾- and full-length portraits. A prerequisite is that there must be a light tone (blond hair, light-colored clothing, etc.) for the black outline to reflect onto.

Chiseled Style. This technique can be very effective when combined with the chiseled light-

ing style, since the black outline is quite compatible with the sharp lines in this style of portrait. When using chiseled-style lighting, however, you must feather the main light across the front of the subject from a 45-degree angle. This will prevent the black panels from blocking the light required to produce the image's high key tones. At the same time, you must ensure that you are not directing light onto the black panels themselves. If light from the main light is directed onto the panels, they will be much less effective.

Soft or Flat Style. Outlining is not recommended for conventional portraits with the soft or the flat look, or when the intention is to create a delicate portrait. However, with a little creativity and forethought, this technique might be creatively used with most of the styles previously described.

Outlining is not normally successful when the subjects are placed at the background. This is because the depth of the panels will not effectively permit any of the lighting patterns that were previously described. Additionally, the reflectance of the background lighting will wash out the potential outlining. If you decide to try to create outlining with the subjects at the background, you will need to use a relatively flat lighting style with a narrow spread of light for it to work at all. A main light with a modifier equipped with a front panel not more than 16" wide with louvers, barn doors or light blockers could be used in this situation.

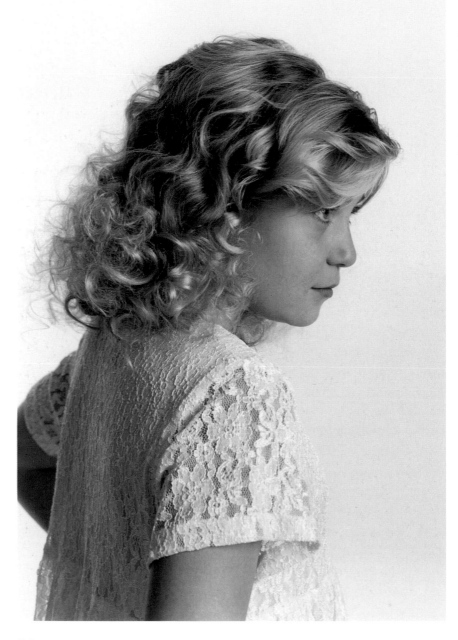

PLATE 56: In this image, the black panels have been placed a little closer to the background. Note the difference between the front edge of the dress in this image and in PLATE 55. The intensity of the outlining will change depending on how close the black panels are placed to the subject.

13. Window Light

AS NOTED PREVIOUSLY, HIGH KEY PORTRAIT OPPORTUNITIES frequently occur outside of the studio. This is especially true for wedding photographers, who never know exactly what situation they may find themselves working in. Equally, the portrait photographer who works on location in clients' homes may well find an opportunity to create high key images.

Window light frequently offers the opportunity to create truly stunning images. Many who practice portrait photography will even claim that there is no better light. This light provides an incredible, almost neverending range of lighting opportunities for portraiture in each of the three keys. When in light and bright surroundings, or a location with white or light-colored walls, high key situations will exist. For the following procedures, we will consider

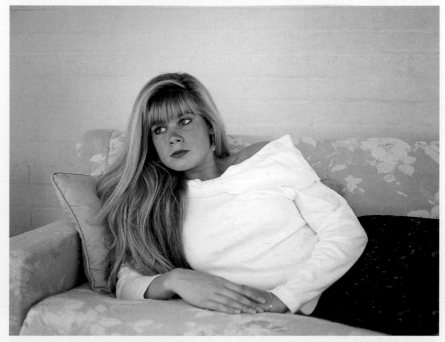

PLATE 57: Here, window light is used to create an overall flat lighting pattern. The portrait remains in high key, as the young woman is in white and the background wall is off-white—at least two f-stops brighter than 18 percent gray.

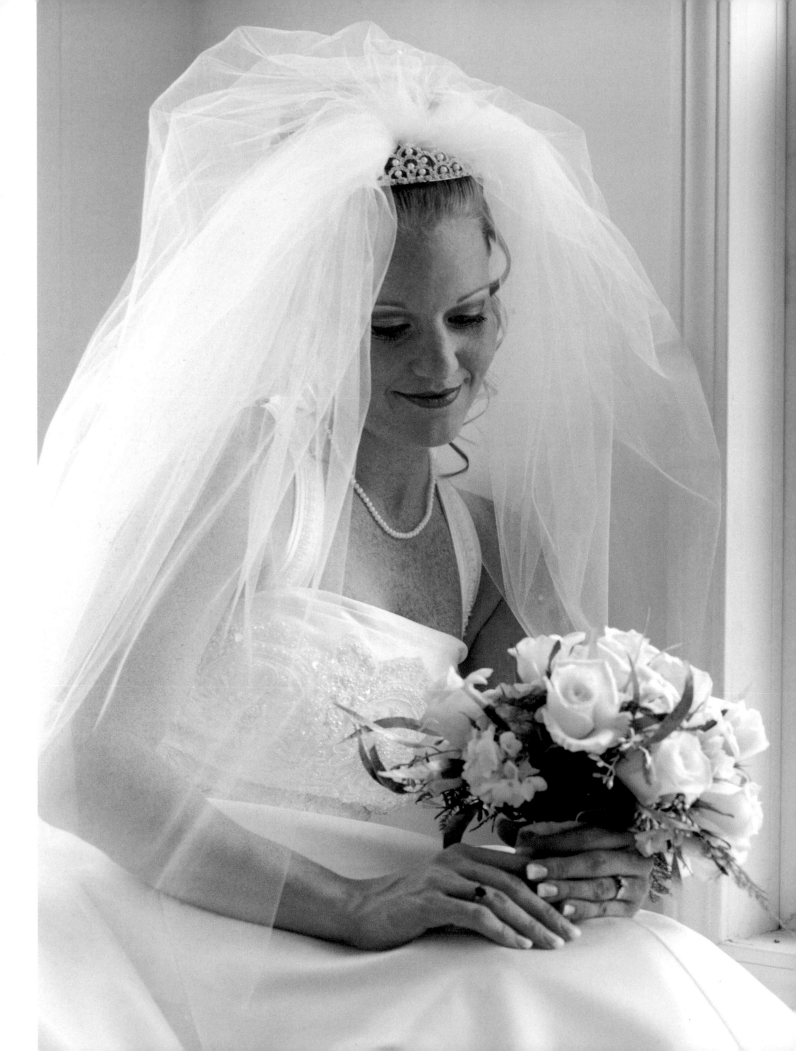

PLATE 58 (FACING PAGE): A bride automatically makes a portrait in high key when she virtually fills the frame. In this case, the walls are also white (though in shadow).

PLATE 59 (ABOVE): "Little Sweethearts" by window light. Light from the window at the right provides the main light, and the light from the window behind provides the kicker light for both the hair and the shoulders, pushing the background into high key.

a portrait made using window light in a room with white walls.

▶ WINDOW LIGHT PORTRAIT

When working with window light instead of using camera room equipment, you will need to adopt a very different approach. Instead of placing lights where you want them, you will have to place the *subject* in a position dictated by the available light.

Exposure and Metering. Begin by metering the available light at the wall you wish to use as a background. Assume, when doing so, that you get a reading of f-5.6. To retain a high key background, this means you will need to find the distance from the background at which you can expose the subject at not more than f-8. This one f-stop is the longest ratio between subject and background you can use and still retain high key tonality. Should it be longer,

even by ⅒ of a stop, then the portrait will fall into the middle key.

In many situations—even with ISO 800 color film—you may even need to expose at f-2.8. In this case, you will almost certainly be in a relatively flat lighting mode and will need to keep your subject close to the wall in order to render the background in high key. At wider apertures like this, you will see that the light falls off much more quickly than at smaller apertures. Because falloff is more pronounced at wider apertures, you need to have your subjects closer to your background.

Light Angle. The second challenge is to select the angle of the light you are going to use as it is directed through the window. The nature of light from windows varies depending on whether the sun comes through an open, a partially clouded or overcast sky. Additionally, the position of the

PLATE 60 (FACING PAGE): An example of split lighting using window light. The young woman is in white, the left-side window provides a low key facial lighting and also acts as a background. The left side of the image, including the window and the subject's beautiful golden hair, is lit in full high key. The right side, including her dress and the background, fall into middle key. The result is a soft, almost mysterious portrait. The splash of light on her nose adds a little sparkle and depth to the form.

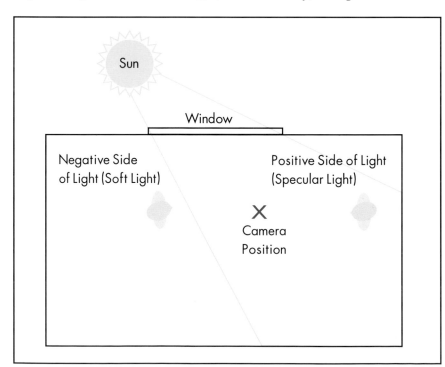

DIAGRAM 12: The positive side of the light is characterized by a specular quality. The negative side offers softer light. Subjects(s) will primarily be facing across the path of the light, as shown in the diagram. However, different lighting patterns can be achieved by turning the subject(s) away from or into the path of the light or toward the camera position. The camera will be directed toward the background, where the light illuminates the high key zone.

Sun

Window

Negative Side of Light (Soft Light)

Positive Side of Light (Specular Light)

X
Camera Position

sun in relation to the window also significantly affects your options.

Depending upon its direction (when not diffused by clouds), the sun can create two distinct styles of light: specular and soft. With such undiffused light, you will want to create your portraits when the sun is directed at an angle across the room, rather than when it is directed straight into the room. This will provide you with the option of creating two different looks. Where the sunlight falls directly on the background wall, it will be specular (creating a more chiseled look). On the opposite side, the light will be softer, and offer the kind of illumination that will produce soft and gentle portraits. Your choices in regard to the direction of the light source and subject placement should be dictated by your recognition of the lighting patterns and your meter readings.

Modifying Window Light. You may also be able to modify the light source, either with existing drapes or with the use of translucent reflector panels (such as the Monte Illuminator), which are available from various manufacturers and come in a number of sizes. With existing drapes, controlling window light is similar to feathering the light in the camera room. The drapes are drawn or opened to control both the intensity of the light on the subject and to create a wider/narrower source of light. In situations where the sun *is not* diffused by cloud, drapes can be used to limit its intensity on the subject. In situations where the sun *is* diffused, open the drapes as much as possible to provide a wider source of light. The variations you will encounter are considerable. In this book, however, we can only describe a few from which, with

PLATE 61 (FACING PAGE): A location high key situation using window light is converted into a split key image, using high key on the left side and low key on the right side (for creative reasons). This is an example of how mixing keys can sometimes be successful.

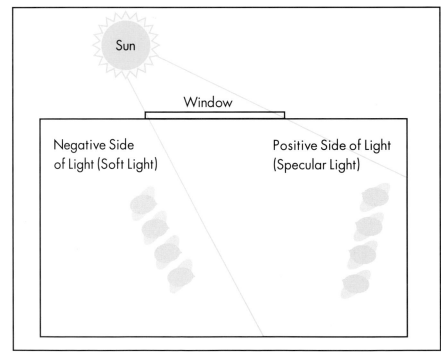

DIAGRAM 13:
Here, a group of four is positioned to keep the light on the high key background as even as possible while effectively lighting the whole group. Therefore the group will be facing across the room and parallel to the opposite wall.

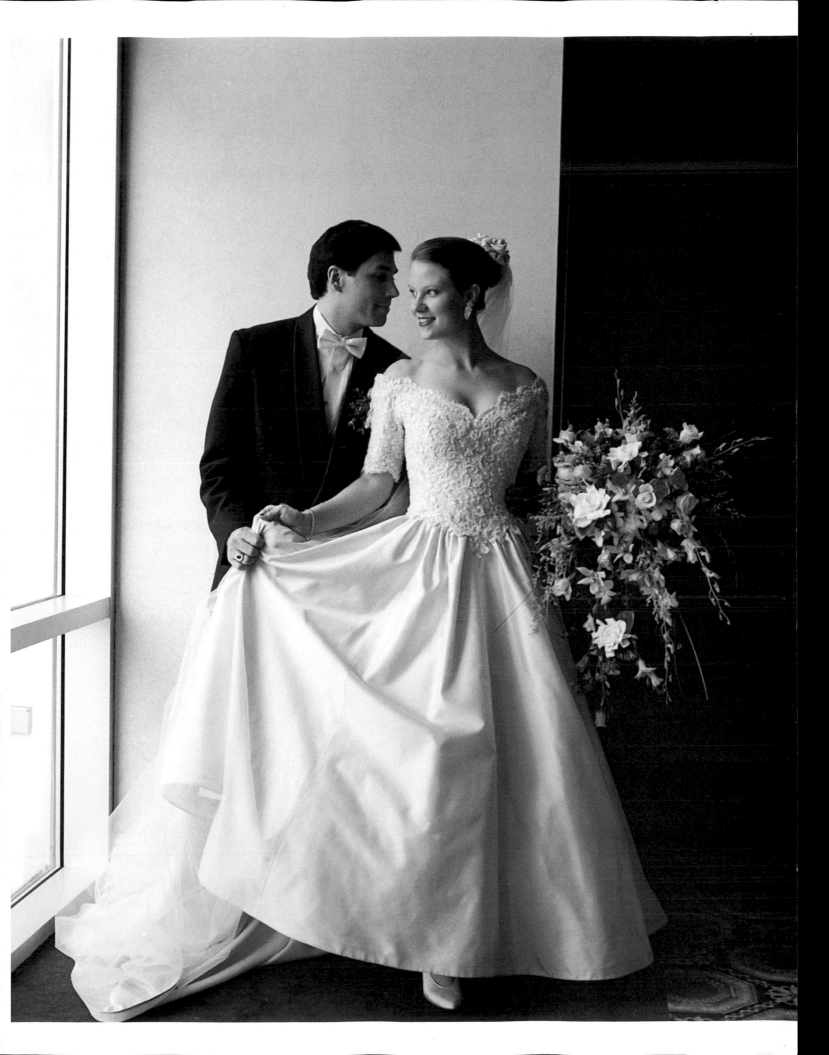

PLATE 62: Weddings often provide natural high key situations. In this portrait, the white wall and the white gown are more than enough to make this a high key window light portrait.

trained observation and practice, you are able to produce a range of attractive portraits.

► SPECULAR WINDOW LIGHT

Let us assume that you have decided to create a portrait using undiffused window light. For this portrait, the camera position will be parallel to the plane of the window and the room's rear wall. In this scenario, the light falls directly onto the white or light-colored wall where the subject is placed. This means that the light will fall on both the subject and the wall at each side of the subject.

Fill Light. Because the light is specular, the ratio between the highlight and shadow sides will be at least 4:1, and possibly 5:1. Because of this, for most portraits, you will want to use a fill light. In most situations, this will mean using a reflector. Since the window light itself is hard, the ideal choice would be to use a silver reflector, which will be complementary to the natural light and also help to reduce the ratio to a greater degree than a white reflector would. This will render a strong image that is well-suited for most male subjects, and for female subjects who desire a dramatic, unconventional look.

Portable Flash. If the ratio is still too long for your taste, you may reduce it to a greater degree by using a portable, off-camera flash that is bounced off the wall opposite the subject (directly behind the camera). This technique works better than direct

flash at the camera position, because an unmodified portable flash is a small light source and will produce a hard shadow on the wall behind the subject.

For on-camera use, a bounce card attachment will significantly soften the light. Many portable flash units also feature a wide-angle adapter that can be placed in front of the flash tube to soften the light by approximately 15–20 percent. Additionally, there are other products available that can be placed in front of the portable flash tube to greatly soften the light. For example, many photographers use miniature, on-camera soft boxes fitted to the flash head. These produce an effect similar to that of the larger soft boxes that were discussed previously.

A much larger fill source, such as an umbrella or a wall, will produce a greater area of illumination around the subject. This will soften the shadows from the main light (the sun), and render the subject more kindly. A larger source is even more important when you are photographing groups, since you will need to position your subjects at an angle to the background wall so that each member of the group is lit similarly. This may mean that the member of the group nearest to the window is at the wall, while the member of the group farthest from the window is 24"–36" (or more) away from it. In this situation, a broad fill light will help to effectively illuminate the background to hold it in high key.

PLATE 63: In this portrait, windows produce both the portrait lighting and the background. The angle of the subject to the window has produced a deliberately extended ratio.

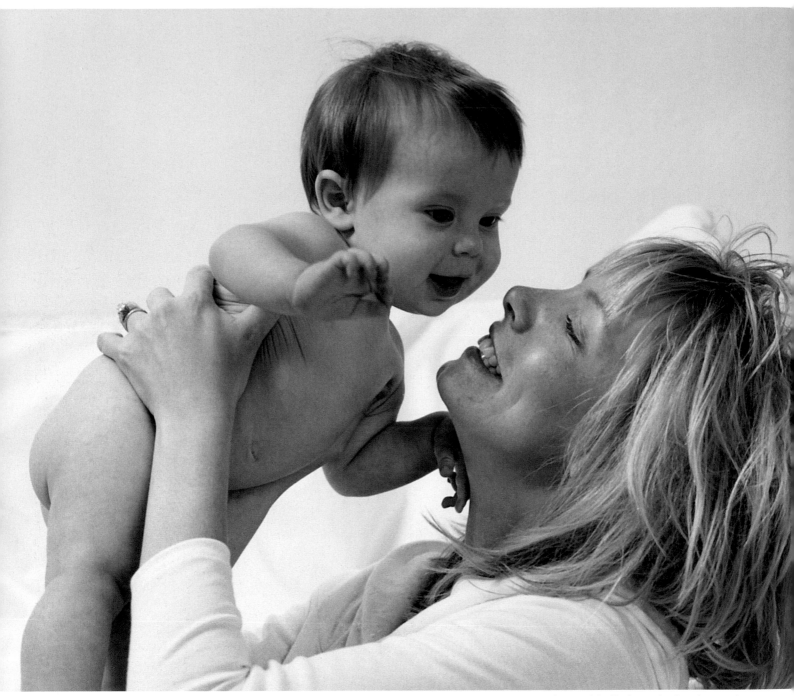

PLATE 64 (ABOVE): This high key portrait was created on location with window light and portable flash on the background.

PLATE 65 (FACING PAGE): Soft to flat daylight, a white window set and a white gown make this an easy high key image.

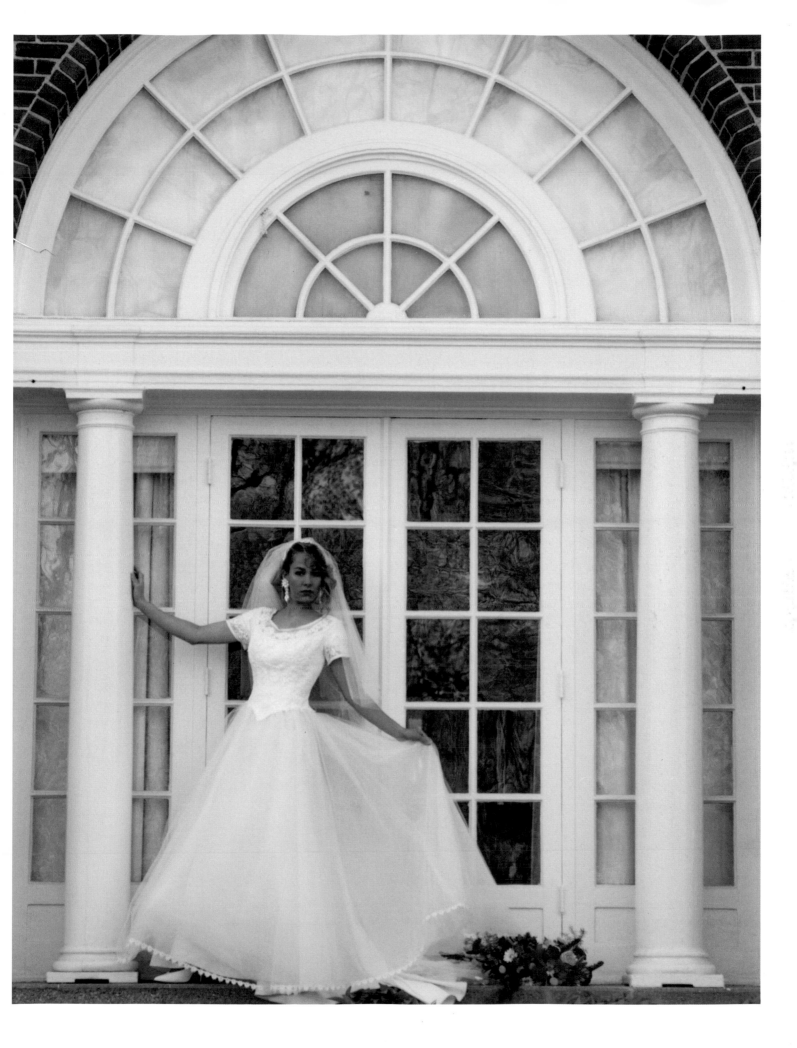

DIAGRAM 13: *On the negative side, light is flatter farther from the window.*

►SOFT WINDOW LIGHT

On this wall, the light is more even and you will find it easier to produce a high key image. You can place your subject close to (or at) the wall, and expose for a portrait that keeps the background in a high key tone. Because the light is softer and appears to wrap around your subject, the shadows on the wall will also be significantly less harsh; the light is angled away from where you have placed your subject, and you are using the soft edge of the light instead of the hard one.

Modifying Window Light. In this situation, you may want to draw the drapes or blinds to create the largest possible light source. This will add to the softness of the light, and provide you with a wide background area to shoot against—as well as with the optimum possible coverage.

Subject Placement. As you place your subjects against the background in this type of situation, you must be careful to observe how the light falls off as you move the person farther from the window. Be careful not to go so far from the window that the light, instead of being soft, becomes flat. When you move too far from the window, the light stops creating shape and modeling on your subjects.

If you do choose to use flat window light, it is advisable to increase your exposure by a full f-stop. This is because, when window light falls off, it does not create the same situation as the flat lighting described in the camera room setups. In this situation, the light is very weak (in comparison to the camera room lights, which are cranked up and placed deliberately to produce the effect).

Fill Light. In this situation, fill light is less important because the overall lighting—though it is soft—provides relatively even coverage.

Exposure. It is recommended that you are generous with your exposure, however, so that you avoid dull shadow areas and inadequate luminance in the skin tones. Underexposure is fairly common in this situation, and the results are often less than satisfactory. The recommendation is that an additional ½ stop be added to the meter reading. In fact, because this type of light is so forgiving, an additional full stop will not result in overexposure and will assist in producing excellent detail in the shadow area.

►WINDOW AS A HIGH KEY BACKGROUND

When window light is used with imagination, you can create some beautiful portraits. Most window light portraits, as discussed so far, are made without showing the window itself, as its overpowering intensity can be distracting. Another way to use window light, however, is to use it to create a high key background. To achieve this, position the subject so that the window becomes the background and illuminates the face. This can produce a number of different styles. When there are two windows at an angle to each other, additional possibilities are presented for creative lighting.

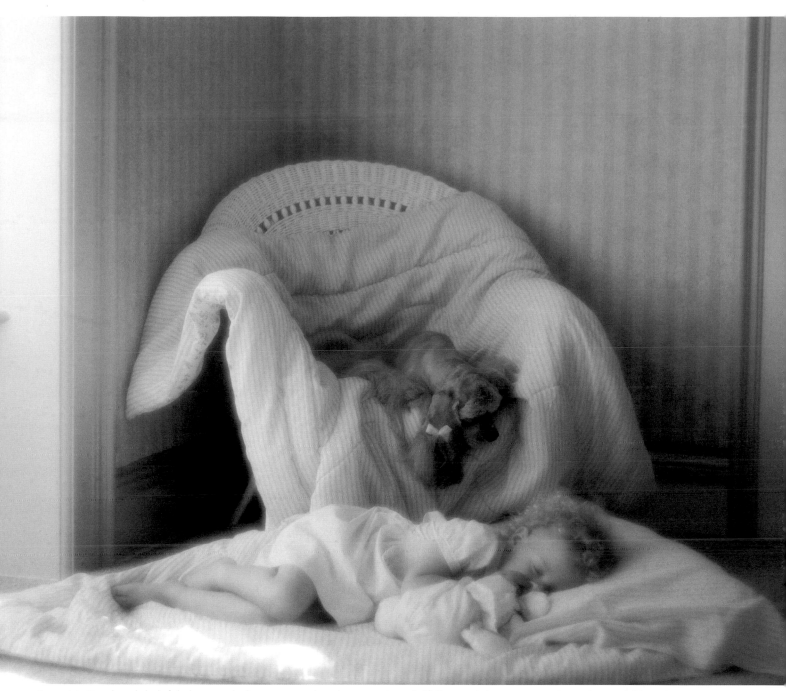

PLATE 66: For this delightful sleeping baby portrait, the photographer skillfully used the existing white elements (the white area near the window, the baby in white and the white comforter) for a high key portrait with window light. The shadowing at the back challenges the high key, but the overall image stays in high key. (Photograph: Dennis Craft)

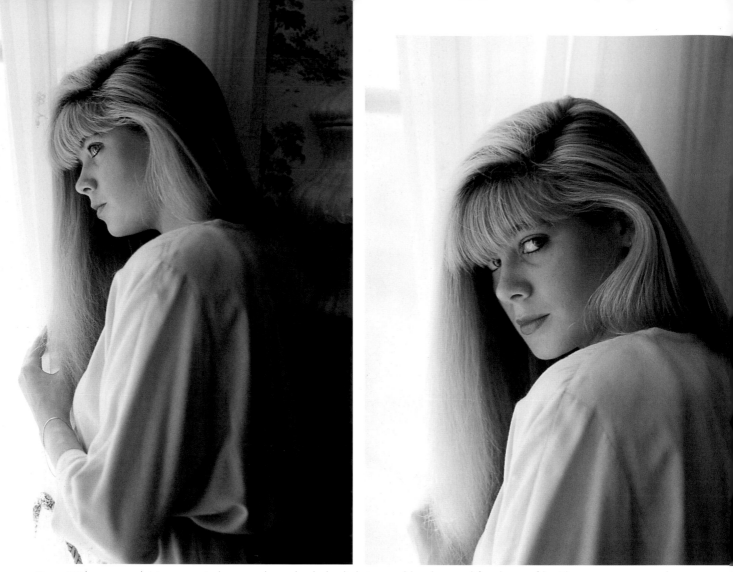

PLATE 67 (ABOVE, LEFT): Here, a window produces both the lighting and background for this profile. This portrait was taken on the negative side of the light with a 3:1 light ratio. PLATE 68 (ABOVE, RIGHT): In the second image, the head was turned slightly away from the window to create a longer ratio because of the angle of the lighting.

► SUPPLEMENTING WINDOW LIGHT
We have discussed the restrictions that natural light can place on us. Now, we can discuss how you can improve your high key look using window light supplemented with flash. You are always wise to carry whatever equipment you might need—never assume that the local conditions will be kind to you. With the right equipment, you can turn difficult situations into winners. This means that, having selected the room in which to work, you can place your subject where the light from the window is most flattering—even if the available light level isn't sufficient to create a high key effect.

Let us assume, for example, that you are able to expose your subject at f-5.6 close to the window, with a white background wall 6' behind. In this situation, it is unlikely that there will be enough light on the background wall to produce a high key tonality. The exposure at the background may be up to two stops darker—probably between f-1.4 and f-1.2. This is much too dark for high key.

Again, assuming that the white background wall is 6' behind the subject, and you wish to render it as high key, dial the manual power of the flash to its lowest number and place it in a position where it will illuminate the entire background behind the subject. Next, take several meter readings in the reflective mode. The first reading is used to ascertain that light on the background behind the subject matches the

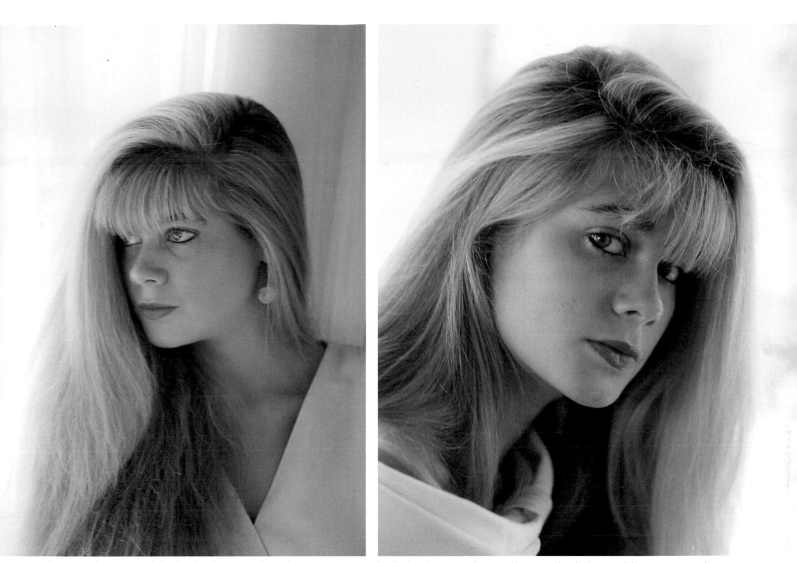

PLATE 69 (ABOVE, LEFT): In the third image, the subject was moved a little closer to the window so the light would wrap around to produce a beautiful 2.5:1 ratio. PLATE 70 (ABOVE, RIGHT): In the fourth image, the subject was turned and centered in front of the window. A second window light was used behind her to create what is a controversial light pattern. There is nothing wrong with challenging the conventional!

exposure of f-5.6. If it does, you will have a background that is at the edge of the high key range, just before it would fall into middle key. Increase the power of the flash in increments and meter each setting until you obtain a reading of f-8, one f-stop greater than the exposure of the subject. This will gradually move the background into a bright, high key tonality.

For fill lighting to create the desired light ratio, place a flash unit at the wall opposite the window (the main light). With the main light at f-8, the fill light should read between f-2.8 and f-4 to create a ratio between 3:1 and 3.5:1. Adjust either the power or the direction of the flash until you achieve the reading that is most appropriate for the result you wish to achieve.

At this time, it is important to take one more reading in the incident exposure mode. This reading is taken at the subject's position and should not indicate an exposure greater than the f-5.6 at which you are exposing the subject. If the reading is greater than f-5.6, then you must adjust the power of the flash or the lighting pattern of the natural light will be compromised. Assuming that the flash unit is set in manual mode at its lowest power, you can either place it farther away from the wall or place a piece of white semi-opaque paper/cloth in front of it to reduce its power. Alternately, you can use a bounce card attached to the flash head, which will also reduce the power. There

are also several attachments available through photographic dealers that work very well in these situations. Another option is to place a scrim—perhaps in a disc form, such as is available from photographic suppliers—in front of the flash. This will create wide, soft light with a reduced intensity.

This technique can be used in almost any natural-light situation where you wish to produce a high key portrait and there are white or light-colored walls. It can also be employed to supplement the lighting on the subject. To do this, you will need to shoot into a corner of the room (place the subject almost directly in a line between the camera and the corner of the room). In this setup, the flash will not only illuminate the background but will bounce off the walls to produce a little fill light that will fall on the sides of the subject.

This is an ideal method to employ when using a harder window light source, as it produces additional illumination in the shadow side of the portrait.

For all of these procedures, it is recommended that meter readings be double-checked—you can never take too many readings. The more readings you take from different positions, the more assured you can be that you have the best possible exposure for the finished portrait.

14. High Key Outdoors

OUTDOOR SITUATIONS THAT PROVIDE ONE WITH HIGH key opportunities abound—from homes painted white and other soft bright colors, to the seashore or lakeside. On a bright day, with the sun slightly cloud-covered, even a cornfield would provide a high key back- and/or foreground. Portraits taken with the subjects positioned so that open or cloud-covered sky provides a background also create a high key situation. There are a few common problems to look out for, however. First, the subjects must be positioned so that they are not looking into direct sunlight, or they will be adversely affected by its intensity. Additionally, you will need to prevent strong sunlight (especially from directly overhead) from creating washed-out skin tones. Strong light directly overhead will also dramatically change the color of a person's hair—so much that dark-haired people will appear blond.

Ideal conditions for portraiture exist in open areas when conditions are partially overcast, either in the early or later hours of the day, and with the position of the sun behind the camera position (or off to either side of the subject's position). In these conditions, there should be no reason to use a flash fill light, though a reflector may be needed.

You can also produce a high key portrait in an open sky situation when the subjects are placed where there is some overhead cover to prevent top lighting, and where we are able to see the open sky as a background. (This is likely to be on a hill or ridge where

Ideal conditions for portraiture exist in open areas when conditions are partially overcast, either in the early or later hours of the day, and with the position of the sun behind the camera position (or off to either side of the subject's position).

PLATE 71: In this location portrait, the bride's gown combined with the white gazebo produces a high key style.

the subjects are elevated so that dark or more subdued tones, such as trees, hedges and buildings [unless white], are not in the background.) This is called subtractive lighting. If natural overhead obstructions (such as tree branches) are not available, you can use man-made blockers to prevent open sunlight (or other bright top light) from falling onto the subjects. In a close-up situation, something as simple as a reflector panel will suffice. This can be suspended on a light stand or held by an assistant. For full-length portraits, more elaborate arrangements must be made: suspending large panels on 8'–10' (or higher) stands covers a much larg-

PLATE 72: *The overall brightness of this scene keeps the portrait of bride and groom in high key. The secret is in the exposure. Half an f-stop less exposure would cause this to be a failure.*

er area than would be possible with a reflector. Keep in mind that, in many adverse weather conditions (such as high winds), suspended panels may act like kites and you can easily lose them. Using weights, such as sandbags, to hold down the stands may prevent this. It is also necessary to properly secure the panels to the stands in order to prevent such a calamity.

▶ USING FLASH

In each of the situations we have discussed in this chapter, portable flash may be used to good effect. A common mistake in bright, sunlit situations is to assume that fill flash will produce a balanced

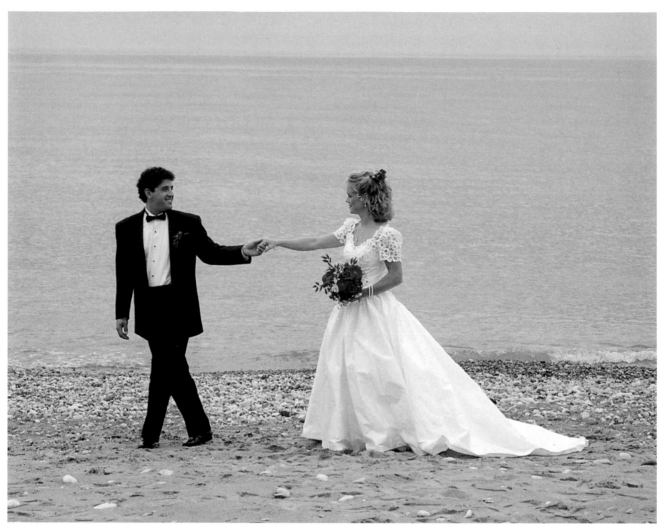

exposure, and reduce or eliminate the effect of the hot sunlight. When the sun is so strong that it washes out skin tones, flash will not reduce its adverse effect. Syncro-sunlight techniques, in which the flash output is matched to the ambient conditions, may be appropriate at times, but they do not usually produce what would be described as good portrait technique.

If you place your subjects in strong sunlight against an open sky, the sun will most likely cause the subjects to merge into the background provided by the sky. Fill flash is not the answer to this problem, since all it will do is reduce the ratio between the washed-out areas and the rest of the skin tones. What this produces is an over-illuminated subject without any real modeling detail.

If you want to use flash, be sure that it provides a balance between highlight and shadow (as you would use it in the camera room). This means you must position your subjects so that the bright areas you are using as a high key background do not adversely affect the lighting pattern on them. If you are using an overhanging tree (or other sub-

PLATE 73 (ABOVE): Keeping this image in high key on an overcast day on the beach required generous exposure. On an overcast day, exposure should be increased up to one f-stop or the result will be drab and lifeless.

PLATE 74 (FACING PAGE): You could not ask for a better natural high key location than this—lots of white walls and a white gown with bright daylight. The darker elements create a frame for the image and the posterization adds additional interest.

PLATE 75: In this profile, the natural open area behind the couple creates a high key background. When the white gown and headpiece are added to the composition, the image is more high key than middle or low key.

tractive lighting element) or panels to accomplish this, then you can use your portable flash as a fill or kicker light—depending on the particular conditions you are working with.

It is most important to ensure that the background you have selected will render at least 1½ stops brighter than the light on the subject, including any additional light you may add with a portable flash. It is equally important that you do not include any part of the tree or other blocker used for subtractive lighting purposes. These dark objects will break down your high key set.

Remember, when a significantly darker element is included in your composition you are mixing keys—exactly what you are trying to avoid.

► ON THE BEACH
Portraits taken on a sandy beach may be made in any of the three keys. Early in the morning, with the sun on the horizon, you will find beautiful lighting and be able to produce some dramatic effects.

At Dawn. Very early in the morning, when the sun is at a low angle just above the horizon, the light skims across the water toward the beach and causes the

water to fall into either middle or low key. For a high key tonality, you need the light to be at a slightly higher angle, so that the sun actually lights the expanse of water and produces a high key background.

Early Morning. A couple of hours later, with the sun at a slightly higher angle, you can place your subjects with the water and the skyline as the background. This means that the subjects will have their backs to the water and the brightly lit background will be high key. With their backs toward the water, you will need to use portable flash to create portrait lighting. You should, however, position the subjects at a slight angle to the water in order to pick up some of the natural light to one side of their faces for modeling. You can then use the flash as a fill light.

Mid-Morning. As the sun moves a bit higher, the sand on the beach will also be brightly lit. This allows you to position subjects so that your scene includes

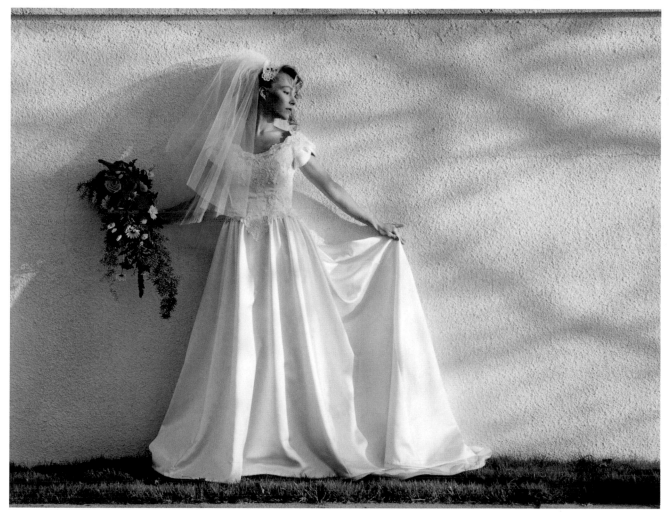

PLATE 76 The use of sun light early in the morning helped create this image in which the shadows from a tree are used as leading lines. Because it was early a 4.5:1 ratio was created to dramatize the pose. There is more than enough brightness to keep it in high key.

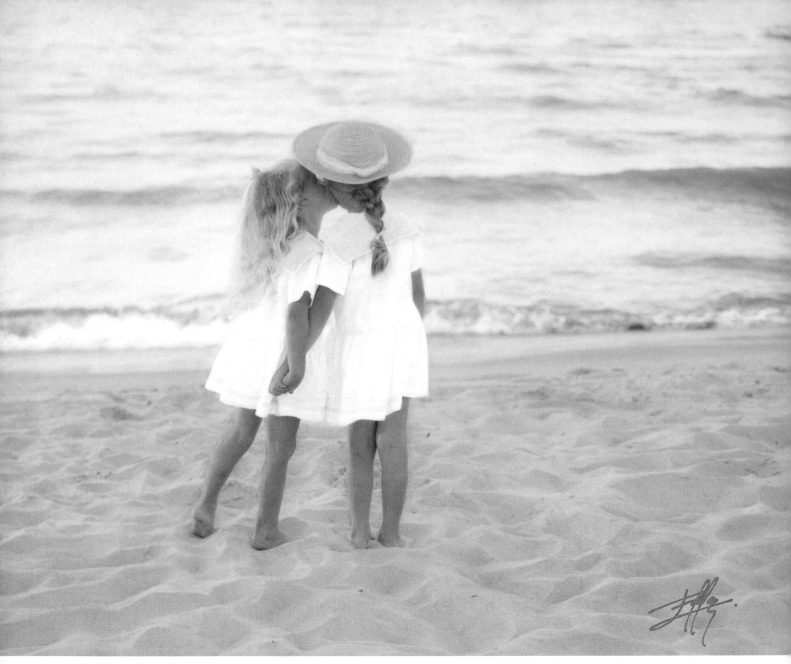

PLATE 77 (ABOVE): In this hand tinted portrait there is a delightful harmony of tones. All the elements are beautifully handled so as to produce a delicate and charming image. Clearly the time of day chosen has had a dramatic influence on the end result. The wrong time of day and this could have been a failure. (Photograph: Edda Taylor.)

PLATE 78 (FACING PAGE): On the beach, slightly overcast sunlight almost brings this portrait into middle key—but not quite. The boys' white shirts tip the scale to produce an average brightness that does not fall into middle key.

some of the beach, as well as the water, and still retain a high key look.

Late Morning. Unless it is at least slightly overcast, late morning light is not recommended for portraiture, as the overhead sun (now at too high an angle) will not allow for the creation of pleasing light patterns. Strong sunlight causes both light-colored and dark-colored hair to appear blond without detail, and subjects may appear to merge with the background.

At each portrait session on the beach, one must carefully select the camera position and its angle to the subject. This is done by observing what will be in the background and the direction of the light. When getting started at a location, it is advisable to take meter readings from the east, north, west and south. These readings will indicate the best position for the subject, and also how much fill light exists (or whether there is need to use flash fill). However, the best method for selecting the subject position, and whether or not to use flash, is by carefully observing the lighting conditions. Your eye is still the best tool for seeing light values.

HINTS AND TIPS

Exposure of these portraits can have a dramatic effect on the key you achieve. If you expose accurately, a nicely balanced portrait will be created. But, if you want to really heat up the high key, overexpose by one full f-stop, then print the image with a little less than normal density. This will produce a really bright, overall high key image. In these outdoor conditions, one can always increase the high key factor with overexposure and under-printing.

15. Composition, Subject Placement and the Use of Props

ONE OF THE MOST IMPORTANT ELEMENTS OF GOOD portraiture is composition. Much is discussed about lighting and posing—and, without a doubt, these elements are vital to the success of the portrait. But, to the viewer, composition also has a significant impact on how the portrait is appreciated. We have discussed mixing keys, which is part of the composition process, but the position of your subjects in the overall presentation of the portrait and how you include other elements makes a critical difference as well.

▶ TOO MUCH WHITE SPACE

In high key, too much open white space in a portrait that has no relevance to the subject will detract from its potential impact. While it is important to not squeeze subjects into your frame, placing a subject randomly in a vast open white space will leave the viewer perplexed. It will also cause their eyes to wander over the empty space. The viewer should be absorbed in the portrait and no element should detract from its impact. Therefore, you must work to achieve a balance in which the point of focus and its important accessories rest comfortably in the overall composition. Open space can be highly effective if used judiciously.

▶ SUBJECT POSITION

When the subject is looking to the right of the composition, rather than directly at the camera, adequate space should be provided for the subject to look into (so that he or she does not appear to

You must work to achieve a balance in which the point of focus and its important accessories rest comfortably in the overall composition.

PLATE 79: In this masterful composition, we see all three keys. The sky and the water behind the boy are clean high key. The tree line in the top third of the image is low key, and the jetty is middle key. Placing the boy so that he is in all three keys makes this mixed-key image a success. (Photograph: Dennis Kraft)

PLATE 80 (RIGHT): This image uses open space in a completely different way—but just as skillfully. It emphasizes the size of the child by letting the space fall way to the right. The slight graying of the base at the right, again, prevents the image from being dominated by too much white space. (Photograph: Kim and Peggy Warmolts)

PLATE 81 (BELOW): Great artists use space to create images of unusual storytelling and impact. In this portrait the maker emphasized the baby's size by using the space in front of him leading us to the point of focus. The slightly gray area leading across the white area directs our eyes to the baby and prevents too much white from overpowering the rest of the image. (Photograph: Dennis Kraft)

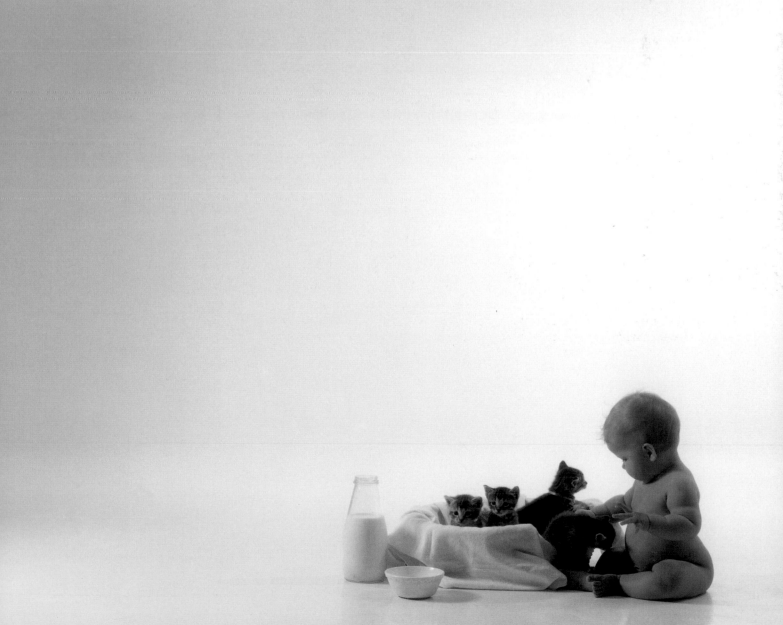

PLATE 82: This portrait is a rare example of how one can successfully place figures in the center of the composition and still have a stunning image. The clothing is in high key, but the background is low key. Though the backdrop is very strong, in and of itself, the power of the pose and expressions cleverly creates an attractive harmony. (Photograph: Edda Taylor)

be staring at the edge of the print). At the same time, too much empty space will leave the viewer's eye to wander into what might be described as a paper abyss. In a head and shoulders image, in which the subject is looking at the camera, the viewer should see approximately a three-quarter face and there should be approximately 5 percent more space left on the side of the image toward which the subject's head is turned. Additionally, you should consider not placing the subject in the middle of the composition. A subject planted in the center of a portrait may seem boring and lack a sense of vitality.

► STORYTELLING PORTRAITURE

In storytelling portraiture, the rules of composition are different. The subject should be placed in such a way as to link it to (and make it relevant to) the props and scenery that are used in the image. You should avoid placing important elements in the composition in such a way as to create more than one point of focus. There should not be multiple stories within the same portrait.

► PROPS AND SCENERY

The use of props or scenery must also be carefully considered. Just because you *have* a prop, or just because scenery is *there*, does not mean you should use it. Every element within our composition must justify its relevance in the portrait. So often, we see portraits that feature stunning scenery—

settings worthy of being presented on their own. What we see in these portraits is *the scene*, which dominates the subject. Magnificent scenery, while awe inspiring, may well overpower the principle point of the image—the subject. In professional print competitions, many photographers enter photographs that incorporate beautiful scenery. They are often successful in the competition, because each portrait is titled in a way that reveals how the scenery relates to the subjects. This instills the judges with anticipation about the story to be presented in the image. For clients, however, you will not usually title portraits. This means that the relevance of the scenery to the subject must be carefully considered. Sometimes, it can be hard to find the subject within a beautiful scene. You need to ask yourself prior to exposure whether the scenery you plan to use is going to enhance the portrait or simply make a pretty picture. There *is* a difference.

The same warning applies to the use of props. There are catalogs full of props for the photographer. You could easily fill your camera room with props galore, and then feel a need to use them—whether or not they contributed positively to your images. If you are professional, your clients may *want* you to include all sorts of props in their portraits. It is best to resist this temptation, however, and to explain why it is not a good idea. In high key, it is

especially important to avoid any props that are larger and significantly darker than the background and the subject's clothing. Such elements will result in distractions within the portraits.

When working in high key, it is advisable to work with props and scenery that will be complementary to the key. Both scenery and props should be as light in color as possible (ideally, white). Strong colors and dark objects may look attractive on their own, but in a high key composition they may compromise the key—unless the predominance of light tones is maintained.

In the portrait of the family of seven (PLATE 83), you will note that the family members are all wearing strong patterns of black and red. High key has been maintained, however, by the white space around the group. If the group had been squeezed into a tighter square composition to show only heads and shoulders and arms, the high key would be somewhat compromised.

Two versions of the little chef image (PLATES 84–85) are shown to illustrate how to limit the impact of props, as important as they may be. The pots, pans, etc., are vital to the story of the image,

HINTS AND TIPS
Primary colors should only be incorporated into a high key image when they can be composed in such a way as to lead the eye to the subject—quite a challenge. This means that their placement needs to be close to the subject and supportive of the subject (or worn by the subject, which could work in a high school senior style portrait against a white background).

titled "Sweet and Sour." In the first version of the portrait (PLATE 84), there are more pots and pans showing than are needed to tell

PLATE 83: Clothing with strong patterns and eye-catching colors (with a lot of black) creates a challenge in posing and grouping. Using diagonal lines, with the black mostly as a base line, and placing the individual's heads at the right intervals overcomes the challenge so that we have a nice portrait.

PLATES 84 (LEFT) AND 85 (BELOW): Here the "Sweet and Sour" portrait is shown in two differently cropped versions. The portrait has much more impact when it is cropped to an almost square shape. While the pots and pans are important, we only need a few to tell the story.

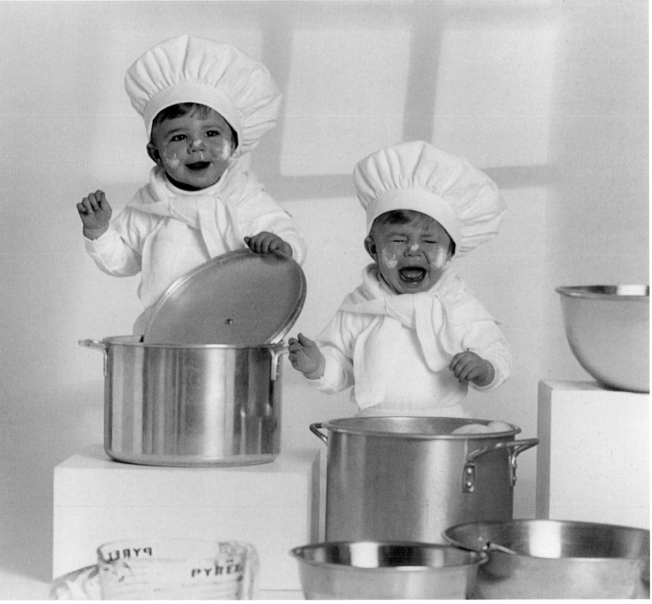

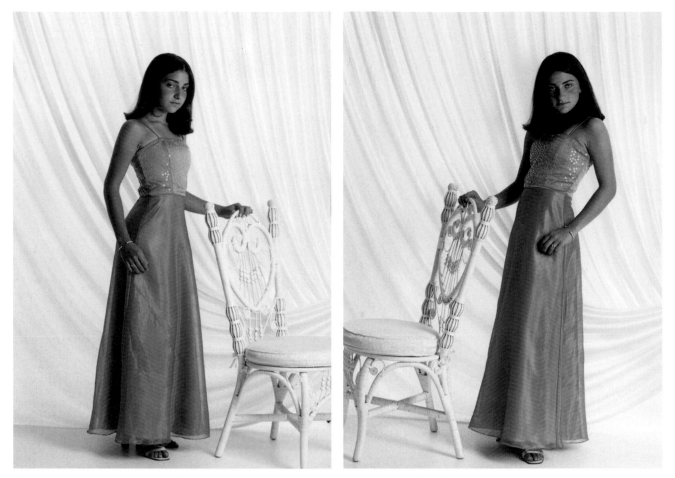

PLATES 86 (LEFT) AND 87 (RIGHT): Compare the poses in these two portraits. When the girl is facing the main light, the image is presentable, but it does not achieve the dynamics and impact gained by having her turn away from it. The portrait has greater character and personality, too, with her head slightly turned into the shadow side, creating a 4:1 ratio.

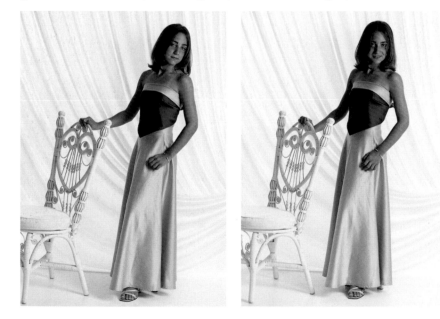

PLATES 88 (LEFT) AND 89 (RIGHT): Here, two nearly identical poses are dramatically differentiated by the angle of the subject's head, which also changes the light ratio. Sometimes, turning the head slightly to create a slightly longer light ratio can be very effective.

the story. This causes the eye to look beyond the central point of the image. In the second version (PLATE 85), the image has been cropped almost square, reducing some of the clutter and resulting in an image with much more impact.

In most instances, portraits created with the subject facing the key light leave a lot to be desired. PLATES 86–87 show two images of a subject, one with the girl facing the key light, and the other with her turned away from it. The subject's head is also turned slightly away to create an interesting, though unconventional, light pattern that appears to create a longer ratio.

Head angles are important, and how they relate to the camera causes them to present very different impressions of the subject.

When posing female subjects, it is important to pay careful attention the position of arms and legs—and also to create as many curves and soft lines as possible. Arms should always have gentle curves, never straight lines. When posing hands, it is normally best to show the sides, not the back or the palm. Legs should be positioned so that they appear as slim and as long as possible.

In the portrait of the bride on the beach (which was used in chapter 1 to demonstrate three keys in a single portrait), the primary point of focus is positioned in the left-hand third of the image (PLATE 91). The subject's head is contained within the lower two-

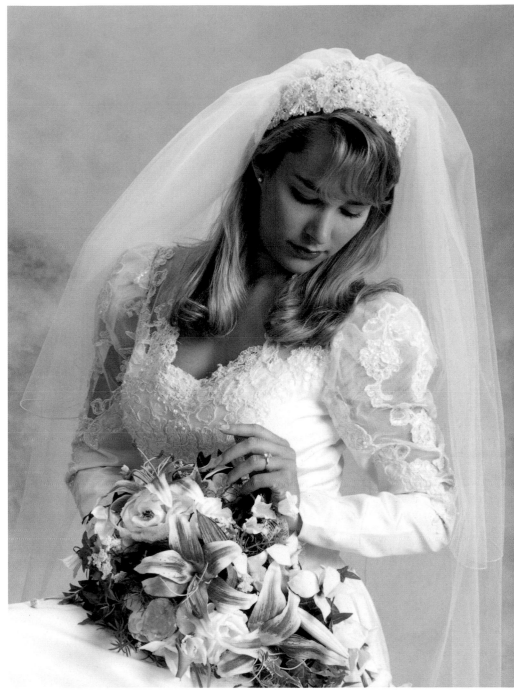

PLATE 90: Many who pose brides forget that inside the gown is a woman. She should be portrayed with as many feminine attributes as possible. By allowing the main light to feather across the beautiful gown, you can both show it off and enhance the bride's bustline. The feminine tilt of the head toward the shoulder and the positioning of her hand to show her ring are both delicately executed.

thirds. The upper third, which is the brightest area within the image, contains the sky. In PLATE 92, the white sky is cropped out, resulting in a much more dynamic image, which is now in middle key.

In the western world, it might have been better to invert this image so that it read left to right. But we now live in a multicultural society, so this composition is quite acceptable—especially as the available light made it the best option. This is a much more effective placement than if the bride were placed in the center of the frame. Additionally, the rocks in the water are used as a contrast to enhance the delicacy of the female form.

Sometimes the simplest poses and arrangements, done without props, have most impact. Photographing six young children can present a challenge. Creating an arrangement that captures the essence of the children and enables you to control their posi-

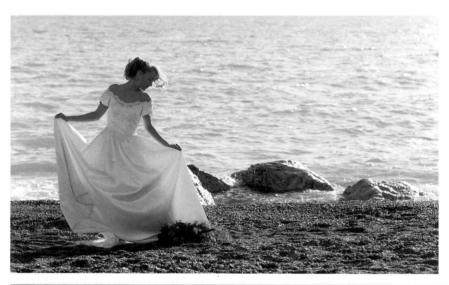

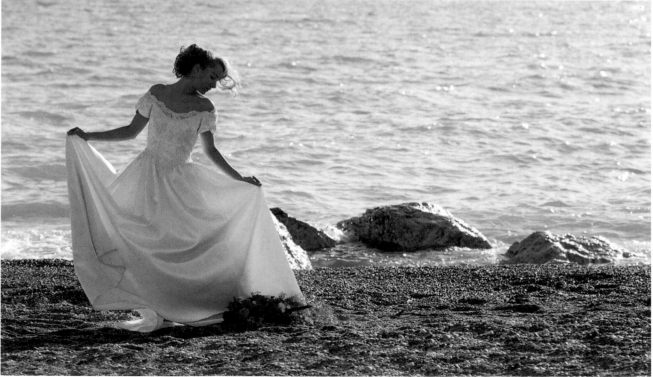

PLATES 91 (LEFT) AND 92 (BELOW): This is a dramatically better presentation of the bride on the beach even though cropping off the white sky causes the image to middle key instead of high key.

tions in the group (difficult with a child's short attention span) can be hard to accomplish. In such a case, reverting to the simplest style may be the best answer. The two arrangements of these six—five boys and a girl—shows two ideas to consider.

PLATES 93 (LEFT) AND 94 (BELOW): Here are two alternative groupings of the same kids. The first is more conventional, though with a slightly longer light ratio. The second group (against the background wall) is much more imaginative, with lots more impact that expresses the individual personalities better—it's a lot more fun, too!

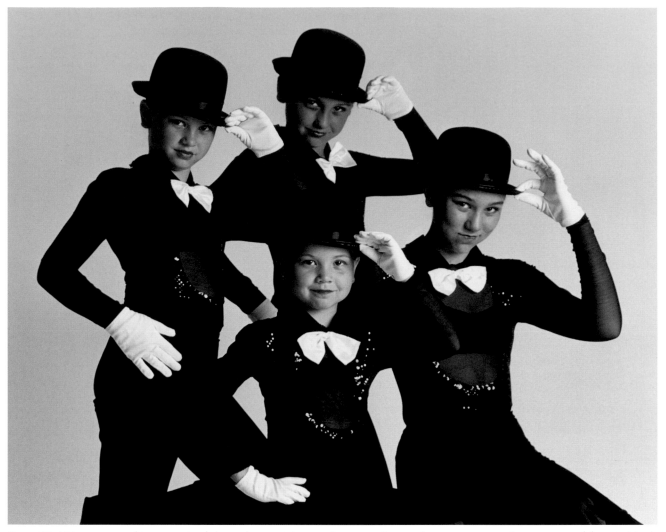

PLATE 95: We return to this portrait of the cabaret girls, simply to emphasize how we may make a group of four in black work to our advantage. Fours are more difficult than other groups but, in this instance, the white gloves and bow ties have been used to create both diagonal and circular patterns. If only the little girl in front had matched the head tilts of the other three!

The portrait of four girls in "Cabaret" offers an easy arrangement because they are all dressed alike and the white gloves and bows help to create circles and diagonals, which are fundamental to arranging groups.

► ENHANCED VARIETY

High key portraiture can be highly appealing when done well. It is ideal for lively children whose body language tell so much about who they are—especially their individual personalities. Using a simple high key background and no props can produce the most delightful candid images of children. We can also produce sequences of images that tell a story about the portrait session. The variety of images produced this way provides choices that are priceless. Variety of choice from a portrait session creates added interest and excitement and elevates us as camera artists.

► SOFTNESS

The softness that we can create in high key with the use of fabrics (discussed in previous chapters) represents small children and babies in an enhanced environment. The same applies to mother and baby portraits and bridal portraits. The white-on-white style produces images that have an ethereal feel unmatched by any other technique.

► ADVANTAGES

In high key, a little imagination and creativity goes a long way toward enhancing the value of our services to our clients. It is important to not get stuck in a rut creating images in the same style every time. If you are not using high key

in your portrait mix, you should seriously consider doing so—especially if professional colleagues in your market are also not doing it. This will provide potential customers in your area with a new option and give you a marketing edge. It will also demonstrate to your market that you are different. There is much to be said for not just being better, but being different. Being different is just as valuable.

► MARKETING

To begin marketing high key as a new product, start by telling everyone that you have a totally new style to offer. This will always create a lot of interest. If you have a display of middle key and low key portraits, consider adding a high key example in the mix—and watch how it will enhance your market share. When we did this in our studio, it caught on very fast and has been a staple element within our product line ever since. It has brought us clients from locations more than three hours' driving time away from our studio—and from cities across the country.

If your professional colleagues *are* doing high key and you have not done so, be sure that (when you do introduce it) you create images that are uniquely different and market them as such. Do not simply copy what others are doing. You can gain a

marketing edge by aping others. Again, you must be different.

► FRAMING AND MATTING

The way you frame and display high key portraits is important. Frames and matting can create a sense of value that enhances your sales. Frames should complement the portrait. The frame must be in a similar vein as the style and dress of the subjects. You should not select a frame for a portrait simply because it appeals to you. Consider the frame a part of the overall composition of the portrait, not as a separate element.

Matting can increase the value of your product. When you visit a museum, you will rarely see images framed without matting. Successful marketers of their artwork always mat their prints. In high key, you must consider the mat as a part of the overall composition of the portrait. Double matting, the method of using mat overlays around the print, can make a significant difference. Some suppliers offer set formats for matted frames and make it easy to present beautiful products to sell to your clients. You may also find a custom framing service that will offer you a trade service, allowing you to be more creative with your framing services.

The options and possibilities that high key provides are never ending, so why not get involved? It is very rewarding!

GLOSSARY

Barn doors—Black, metal or fiber folding doors that attach to a light's reflector. Used to control the width of the beam of light.

Blockers—Panels used to prevent light from falling in areas where it is not wanted.

Boom—An adjustable, pole-like arm used to hold a light or lighting accessory. May be mounted on a stand or a wall.

Bounce flash—A method of flash lighting that uses bright surfaces to redirect the light.

Box light—A diffused light source housed in box-shaped reflector. Such lights have a range of different interior materials that produce different qualities of light.

Butterfly lighting—One of the basic portrait lighting patterns, characterized by a high key light placed directly in line with the subject's nose. Under the nose, this produces a butterfly-shaped shadow that does not spill onto the opposite side of the face.

Catchlight—The specular highlights that are reflected in the pupil or iris of the eye. Caused by the main or fill lights.

Chisel lighting—A lighting technique used to produce sharp definition between highlight and shadow areas.

Composition—Designing of an image. The arrangement of elements in a photograph.

Cookie—An insert placed in front of a spotlight that has patterns that are projected onto a background.

Feathering—Deliberately directing light so that the edge (not the center) of the beam illuminates the subject. This influences the light ratio.

Fill light—Secondary light used to fill in the shadows created by the main light. Also influences the light ratio.

Flag—An adjustable square or rectangular panel that is clipped onto the light reflector.

Flat lighting—A light source or style that produces little or no modeling of the face.

Gobo—Light-blocking card that is attached either to the light reflector, or supported by a boom or stand.

Guide number—Number used to rate the power of studio and portable flash units. You can determine the flash output at a given distance by dividing the guide number by that distance.

Hair light—A light placed over a subject to provide detail in the hair.

High key lighting—Type of lighting used to create a light ratio by highlighting one side of the face and creating a desired density of shadow on the opposite side.

Hot—Describes a light source that is relatively or totally unmodified.

Hot spots—Excessively bright areas in an image caused by overexposure of a particular area of the negative that is out of character with the rest of the lighting pattern.

Kicker light—A backlight, or light placed to the side of a subject, that highlights the hair or contour of the figure.

Lighting key—Defines the overall tonal range of a portrait.

Light ratio—The difference between the intensity of the main light, which highlights one side of the face, and the fill light, which reduces the intensity of the shadow on the opposite side. High ratios are described as long, low ratios are described as short.

Loop lighting—A portrait lighting pattern characterized by a loop-like shaped shadow under the subject's nose caused by the main light.

Low key—An image that has significantly more dark tones than light tones.

Main light—The light used to create a lighting pattern that defines the subject.

Modifier—An accessory used to change the quality of illumination from a light source.

Pan reflector—A shallow metal reflector with a center deflector that produces a relatively hot, but flat lighting pattern.

Portable flash—A flash unit or kit with independent power

that may be easily carried and used without the use of a stand or tripod.

Reflector—A white, gold or silver card, disc or panel used to redirect light onto the subject. Also, an attachment to the lighting unit used to control the spread of light.

Scrim—A fabric panel placed between the light source and the subject to modify the light.

Soft lighting—Lighting style that produces a relatively short light ratio.

Specular—An unmodified (or partially unmodified) light source. May also be described as hard.

Specular highlights—Sharp, dense image points on the negative. These appear as bright spots in the print.

Spill kills—A relatively shallow, circular reflector that is attached to the light head and prevents unwanted spill of the light.

Split lighting—Portrait lighting that renders the subject in two distinct areas in which one side of the face is wholly or virtually without any discernable shadow detail.

Subtractive lighting—Lighting technique that uses a black card or panel to block light from an area in order to better define the light ratio.

Umbrella lighting—Refers to modifying the light by using an umbrella modifier.

Washed out—An area of an image that is overexposed and lacks detail and texture.

Wraparound lighting—A soft type of light, produced by umbrellas and other types of modifiers, that hits both sides of the subject, producing a short ratio and a relatively bright overall image.

Zebra—An umbrella that has alternating white and silver panels. It produces a slightly specular light source.

INDEX

Other Books from
Amherst Media

Wedding Photographer's Handbook

Robert and Sheila Hurth

A complete step-by-step guide to succeeding in the world of wedding photography. Packed with shooting tips, equipment lists, must-get photo lists, business strategies, and much more! $29.95 list, 8½x11, 176p, index, 100 b&w and color photos, diagrams, order no. 1485.

Outdoor and Location Portrait Photography
2nd Edition

Jeff Smith

Learn how to work with natural light, select locations, and make clients look their best. Step-by-step discussions and helpful illustrations teach you the techniques you need to shoot outdoor portraits like a pro! $29.95 list, 8½x11, 128p, 60+ full-color photos, index, order no. 1632.

Wedding Photography:
CREATIVE TECHNIQUES FOR LIGHTING AND POSING, 2nd Edition

Rick Ferro

Creative techniques for lighting and posing wedding portraits that will set your work apart from the competition. Covers every phase of wedding photography. $29.95 list, 8½x11, 128p, full-color photos, index, order no. 1649.

Lighting Techniques for Photographers

Norman Kerr

This book teaches you to predict the effects of light in the final image. It covers the interplay of light qualities, as well as color compensation and manipulation of light and shadow. $29.95 list, 8½x11, 120p, 150+ color and b&w photos, index, order no. 1564.

Infrared Photography Handbook

Laurie White

Covers black and white infrared photography: focus, lenses, film loading, film speed rating, batch testing, paper stocks, and filters. Black & white photos illustrate how IR film reacts. $29.95 list, 8½x11, 104p, 50 b&w photos, charts & diagrams, order no. 1419.

How to Operate a Successful Photo Portrait Studio

John Giolas

Combines photographic techniques with practical business information to create a complete guide book for anyone interested in developing a portrait photography business (or improving an existing business). $29.95 list, 8½x11, 120p, 120 photos, index, order no. 1579.

Fashion Model Photography

Billy Pegram

For the photographer interested in shooting commercial model assignments, or working with models to create portfolios. Includes techniques for dramatic composition, posing, selection of clothing, and more! $29.95 list, 8½x11, 120p, 58 photos, index, order no. 1640.

Creating World-Class Photography

Ernst Wildi

Learn how any photographer can create technically flawless photos. Features techniques for eliminating technical flaws in all types of photos—from portraits to landscapes. Includes the Zone System, digital imaging, and much more. $29.95 list, 8½x11, 128p, 120 color photos, index, order no. 1718.

Black & White Portrait Photography

Helen T. Boursier

Make money with b&w portrait photography. Learn from top b&w shooters! Studio and location techniques, with tips on preparing your subjects, selecting settings and wardrobe, lab techniques, and more! $29.95 list, 8½x11, 128p, 130+ photos, index, order no. 1626

The Beginner's Guide to Pinhole Photography

Jim Shull

Take pictures with a camera you make from stuff you have around the house. Develop and print the results at home! Pinhole photography is fun, inexpensive, educational and challenging. $17.95 list, 8½x11, 80p, 55 photos, charts & diagrams, order no. 1578.

Profitable Portrait Photography

Roger Berg

A step-by-step guide to making money in portrait photography. Combines information on portrait photography with detailed business plans to form a comprehensive manual for starting or improving your business. $29.95 list, 8½x11, 104p, 100 photos, index, order no. 1570.

Professional Secrets for Photographing Children
2nd Edition

Douglas Allen Box

Covers every aspect of photographing children on location and in the studio. Prepare children and parents for the shoot, select the right clothes capture a child's personality, and shoot storybook themes. $29.95 list, 8½x11, 128p, 80 full-color photos, index, order no. 1635.

Handcoloring Photographs Step by Step

Sandra Laird & Carey Chambers

Learn to handcolor photographs step-by-step with the new standard in handcoloring reference books. Covers a variety of coloring media and techniques with plenty of colorful photographic examples. $29.95 list, 8½x11, 112p, 100+ color and b&w photos, order no. 1543.

Special Effects Photography Handbook

Elinor Stecker-Orel

Create magic on film with special effects! Little or no additional equipment required, use things you probably have around the house. Step-by-step instructions guide you through each effect. $29.95 list, 8½x11, 112p, 80+ color and b&w photos, index, glossary, order no. 1614.

Family Portrait Photography

Helen Boursier

Learn from professionals how to operate a successful portrait studio. Includes: marketing family portraits, advertising, working with clients, posing, lighting, and selection of equipment. Includes images from a variety of top portrait shooters. $29.95 list, 8½x11, 120p, 123 photos, index, order no. 1629.

The Art of Infrared Photography, *4th Edition*

Joe Paduano

A practical guide to the art of infrared photography. Tells what to expect and how to control results. Includes: anticipating effects, color infrared, digital infrared, using filters, focusing, developing, printing, handcoloring, toning, and more! $29.95 list, 8½x11, 112p, 70 photos, order no. 1052

Photographer's Guide to Polaroid Transfer
2nd Edition

Christopher Grey

Step-by-step instructions make it easy to master Polaroid transfer and emulsion lift-off techniques and add new dimensions to your photographic imaging. Fully illustrated every step of the way to ensure good results the very first time! $29.95 list, 8½x11, 128p, 50 full-color photos, order no. 1653.

Black & White Landscape Photography

John Collett and David Collett

Master the art of b&w landscape photography. Includes: selecting equipment (cameras, lenses, filters, etc.) for landscape photography, shooting in the field, using the Zone System, and printing your images for professional results. $29.95 list, 8½x11, 128p, 80 b&w photos, order no. 1654.

Wedding Photojournalism

Andy Marcus

Learn the art of creating dramatic unposed wedding portraits. Working through the wedding from start to finish you'll learn where to be, what to look for and how to capture it on film. A hot technique for contemporary wedding albums! $29.95 list, 8½x11, 128p, b&w, over 50 photos, order no. 1656.

Studio Portrait Photography of Children and Babies
2nd Edition

Marilyn Sholin

Learn to work with the youngest portrait clients to create images that will be treasured for years to come. Includes tips for working with kids at every developmental stage, from infant to preschooler. Features: lighting, posing and much more! $29.95 list, 8½x11, 128p, 90 full-color photos, order no. 1657.

Professional Secrets of Wedding Photography

Douglas Allen Box

Over fifty top-quality portraits are individually analyzed to teach you the art of professional wedding portraiture. Lighting diagrams, posing information and technical specs are included for every image. $29.95 list, 8½x11, 128p, order no. 1658.

Photo Retouching with Adobe® Photoshop®

Gwen Lute

Designed for photographers, this manual teaches every phase of the process, from scanning to final output. Learn to restore damaged photos, correct imperfections, create realistic composite images and correct for dazzling color. $29.95 list, 8½x11, 120p, 60+ photos, order no. 1660.

Creative Lighting Techniques for Studio Photographers

Dave Montizambert

Master studio lighting and gain complete creative control over your images. Whether you are shooting portraits, cars, tabletop or any other subject, Dave Montizambert teaches you the skills you need to confidently create with light. $29.95 list, 8½x11, 120p, 80+ photos, order no. 1666.

Storytelling Wedding Photography

Barbara Box

Barbara and her husband shoot as a team at weddings. Here, she shows you how to create outstanding candids (which are her specialty), and combine them with formal portraits (her husband's specialty) to create a unique wedding album. $29.95 list, 8½x11, 128p, 60 b&w photos, order no. 1667.

Fine Art Children's Photography

Doris Carol Doyle and Ian Doyle

Learn to create fine art portraits of children in black & white. Included is information on: posing, lighting for studio portraits, shooting on location, clothing selection, working with kids and parents, and much more! $29.95 list, 8½x11, 128p, 60 photos, order no. 1668.

Infrared Portrait Photography

Richard Beitzel

Discover the unique beauty of infrared portraits, and learn to create them yourself. Included is information on: shooting with infrared, selecting subjects and settings, filtration, lighting, and much more! $29.95 list, 8½x11, 128p, 60 b&w photos, order no. 1669.

Marketing and Selling Black & White Portrait Photography

Helen T. Boursier

A complete manual for adding b&w portraits to the products you offer clients (or offering exclusively b&w photography). Learn how to attract clients and deliver the portraits that will keep them coming back. $29.95 list, 8½x11, 128p, 50+ photos, order no. 1677.

Innovative Techniques for Wedding Photography

David Neil Arndt

Spice up your wedding photography (and attract new clients) with dozens of creative techniques from top-notch professional wedding photographers! $29.95 list, 8½x11, 120p, 60 photos, order no. 1684.

Infrared Wedding Photography

Patrick Rice, Barbara Rice & Travis Hill

Step-by-step techniques for adding the dreamy look of black & white infrared to your wedding portraiture. Capture the fantasy of the wedding with unique ethereal portraits your clients will love! $29.95 list, 8½x11, 128p, 60 images, order no. 1681.

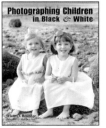

Photographing Children in Black & White

Helen T. Boursier

Learn the techniques professionals use to capture classic portraits of children (of all ages) in black & white. Discover posing, shooting, lighting and marketing techniques for black & white portraiture in the studio or on location. $29.95 list, 8½x11, 128p, 100 photos, order no. 1676.

Dramatic Black & White Photography
SHOOTING AND DARKROOM TECHNIQUES
J.D. Hayward

Create dramatic fine-art images and portraits with the master b&w techniques in this book. From outstanding lighting techniques to top-notch, creative darkroom work, this book takes b&w to the next level! $29.95 list, 8½x11, 128p, order no. 1687.

Posing and Lighting Techniques for Studio Photographers
J.J. Allen

Master the skills you need to create beautiful lighting for portraits of any subject. Posing techniques for flattering, classic images help turn every portrait into a work of art. $29.95 list, 8½x11, 120p, 125 full-color photos, order no. 1697.

Studio Portrait Photography in Black & White
David Derex

From concept to presentation, you'll learn how to select clothes, create beautiful lighting, prop and pose top-quality black & white portraits in the studio. $29.95 list, 8½x11, 128p, 70 photos, order no. 1689.

Watercolor Portrait Photography
THE ART OF POLAROID SX-70 MANIPULATION
Helen T. Boursier

Create one-of-a-kind images with this surprisingly easy artistic technique. $29.95 list, 8½x11, 128p, 200+ color photos, order no. 1698.

Techniques for Black & White Photography
CREATIVITY AND DESIGN
Roger Fremier

Harness your creativity and improve your photographic design with these techniques and exercises. From shooting to editing your results, it's a complete course for photographers who want to be more creative. $19.95 list, 8½x11, 112p, 30 photos, order no. 1699.

Corrective Lighting and Posing Techniques for Portrait Photographers
Jeff Smith

Learn to make every client look his or her best by using lighting and posing to conceal real or imagined flaws—from baldness, to acne, to figure flaws. $29.95 list, 8½x11, 120p, full color, 150 photos, order no. 1711.

Basic Digital Photography
Ron Eggers

Step-by-step text and clear explanations teach you how to select and use all types of digital cameras. Learn all the basics with no-nonsense, easy to follow text designed to bring even true novices up to speed quickly and easily. $17.95 list, 8½x11, 80p, 40 b&w photos, order no. 1701.

Make-Up Techniques for Photography
Cliff Hollenbeck

Step-by-step text paired with photographic illustrations teach you the art of photographic make-up. Learn to make every portrait subject look his or her best with great styling techniques for black & white or color photography. $29.95 list, 8½x11, 120p, 80 full-color photos, order no. 1704.

Professional Secrets of Natural Light Portrait Photography
Douglas Allen Box

Learn to utilize natural light to create inexpensive and hassle-free portraiture. Beautifully illustrated with detailed instructions on equipment, setting selection and posing. $29.95 list, 8½x11, 128p, 80 full-color photos, order no. 1706.

Portrait Photographer's Handbook
Bill Hurter

Bill Hurter has compiled a step-by-step guide to portraiture that easily leads the reader through all phases of portrait photography. This book will be an asset to experienced photographers and beginners alike. $29.95 list, 8½x11, 128p, full color, 60 photos, order no. 1708.